EXPLORING
Art Quilts

with STUDIO ART QUILT ASSOCIATES, INC.

Vol. 3 | Museum Quality

STUDIO ART QUILT ASSOCIATES, INC.

Managing editor: Martha Sielman
Art director: Deidre Adams
Art Quilt Quarterly **editor**: Sandra Sider
AQQ: **Artists to Watch contributing editor**: Diane Howell

ABOUT SAQA

Studio Art Quilt Associates, Inc. (SAQA) is an international nonprofit organization whose mission is to promote the art quilt. Founded in 1989, SAQA now has over 4,000 members worldwide: artists, teachers, collectors, gallery owners, museum curators, and art quilt enthusiasts.

SAQA is dedicated to bringing beautiful, thought-provoking, cutting-edge artwork to venues across the globe. With access to a museum-quality exhibition program, SAQA members challenge the boundaries of art and change perceptions about contemporary fiber art. These exhibitions not only give artists the opportunity to show their work, but also expose the public to the variety and complexity of the art quilt medium.

SCHIFFER
PUBLISHING

4880 Lower Valley Road · Atglen, PA 19310

In this issue

9

168

On the front cover:
Caryl Bryer Fallert-Gentry. *Corona II: Solar Eclipse* (detail)

On the back cover:
Deborah Fell. *Faces in Cages* **(detail)**

On the inside front cover:
Left: Pat Bishop. *Nutmeg* (detail). *Right:* Marcia DeCamp.
River Styx (detail).

FEATURED ARTICLES

48

92

JURIED GALLERIES

INTERVIEWS

Art Quilts in Major Museum Collections

MARTHA SIELMAN, SAQA EXECUTIVE DIRECTOR

The art quilt medium has been gaining increasing acceptance and visibility in the fine art world.

With access to a museum-quality exhibition program, SAQA members challenge the boundaries of art and change perceptions about contemporary fiber art. SAQA's exhibitions not only give artists the opportunity to show their work but also expose the public to the variety and complexity of the art quilt medium.

This volume of **Exploring Art Quilts with SAQA, Volume 3: Museum Quality** brings you a sampling of art quilt collections held in five different museums across the United States: the Museum of Arts and Design in New York, the San Jose Museum of Quilts & Textiles, the National Quilt Museum in Paducah, the Museum of Fine Arts in Boston, and the Renwick Gallery at the Smithsonian in Washington, DC. Each collection has a different focus and each has exciting treasures to learn about.

SAQA is dedicated to bringing beautiful, thought-provoking, cutting-edge artwork to viewers across the globe.

As executive director, one of my most rewarding experiences is to be able to share art quilts in a wide variety of venues showcasing the work of our artists. SAQA travels approximately 17 global exhibitions and 30 regional exhibitions each year, which are seen by thousands of visitors in venues across the United States and around the world.

SAQA exhibition themes cover a wide variety of topics, from protecting the environment to celebrating how we are all connected to the marvel of microscopic worlds to exploration of unusual materials for creating art. This volume of the series showcases work from two of SAQA's exhibitions: **Light the World** and **Primal Forces: Earth**. Readers can find images of the art in SAQA's other traveling exhibitions on the SAQA website at www.SAQA.com/art.

Many of the artists in **Light the World** found that this exhibition was an opportunity to explore light as a metaphor during the 2020 pandemic. Chiaki

Dosho's *The Glistening Light* celebrates how Nature continues to grow and comfort us even when we must be confined to our homes. Lena Meszaros proclaims that *We are all Lights* as she considers how we need to take ownership of the future.

Nancy Woods created a beautiful skyline whose city lights are reflected in water, while Sarah Ann Smith's *Canticle of Stars* captures the movement of the stars throughout a long night. Meredith Grimsley's *Reclaiming My Birthright: Call to My Future Self* looks to light within, while Vicki Conley is dazzled by the light piercing through a *Slot Canyon* in the US Southwest.

The first in a three-exhibition series, **Primal Forces: Earth** explores a variety of artistic approaches to the importance of our Earth. Some of the work is realistic: *Crumbling* by Janet Windsor shows rocks tumbling down a cliff to become pebbles at the seashore, and Brenda Smith celebrates the beauty of the Colorado River's Glen Canyon. Some of the work is abstract: Victoria Findlay Wolfe plays with the patterns formed by leaf and tree shapes, while Shin-hee Chin's *The Web of Life–Earth* explores the interdependence of our relationships with the Earth and all those who inhabit it.

Other pieces carry an environmental message: Jean Sredl's *After the Warming–Permanent Winter* envisions what the landscape might look like if pollution blocks out the sun and plunges the earth into an ice age. And Helen Geglio honors Rachel Carson and her call for better environmental stewardship in her *Wisdom Cloak: The Sibyl*.

Exploring Art Quilts with SAQA, Volume 3: Museum Quality also includes in-depth interviews with sixteen SAQA artists showing examples of their work, information about how they started working in this medium, and stories of what inspires them. These artists are drawn together by their love of fabric and thread, but their work is very different.Studio Art Quilt Associates, Inc. (SAQA) is an international organization with more than 4,000 artists in 39 countries around the world. About 10 percent of SAQA members go through a rigorous application process to be designated as Juried Artist members. They submit a résumé, an artist statement, and a body of work to a review panel made up of existing Juried Artist members. Successful applicants then have their art featured on the SAQA website and in SAQA's *Art Quilt Quarterly* magazine.

For this volume, we are showcasing art by SAQA's Juried Artist members in seven themed galleries. **Tactile & Textural** features art with either actual three-dimensional texture or with so much visual texture that the viewer wants to reach out and touch it. While **Power of Nature** shows different depictions of flowers, birds, bears, iguanas, and dragonflies, **Sense of Place** explores the drama of place, real or imaginary, from ancient stone steps to island marshes to a sky full of floating lanterns. Many artists use their art to express how they feel about current events and the state of the world. View their powerful statements in **Commentary**. We have included the artists' websites so that you can find out more about them and their art.

With this volume's bounty of ideas from museums and artists, we hope to inspire you to new heights of quality in your own creativity. Please visit www.SAQA.com for more inspiration and thousands of images of beautiful art!

Primal Forces: Earth

All life on this planet depends on Earth. However, the soil beneath our feet that nurtures us can be a destructive force. Seismic activity and mudslides have shaped the landscape for millions of years, taking a toll on living beings as well.

Stephanie Nordlin
Arizona, USA
Sonoran Spring
40 × 36 × 34 inches, 2020

Ana Paula Brasil
Ontario, Canada
Earth Womb
84 × 58 inches, 2020

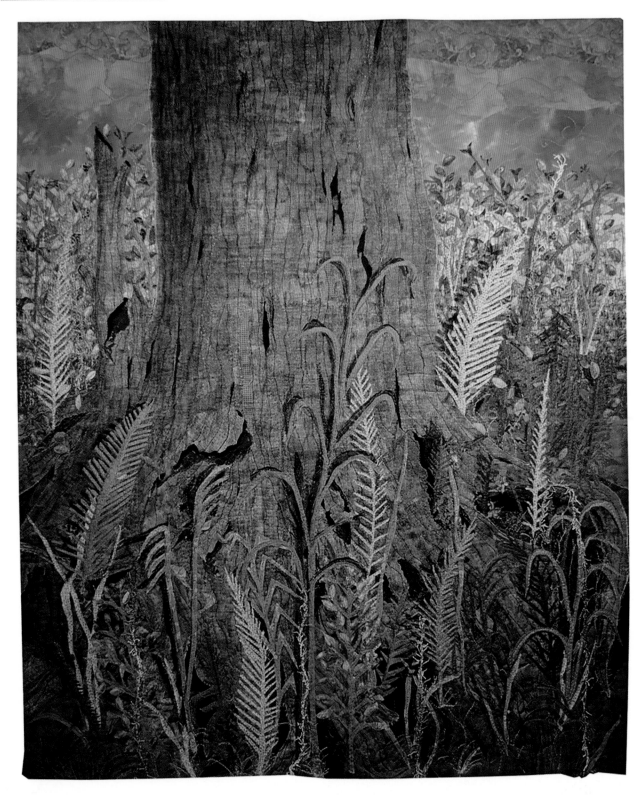

Kathy Menzie
Kansas, USA
Growth, Decay, Renewal
31 × 26 inches, 2020

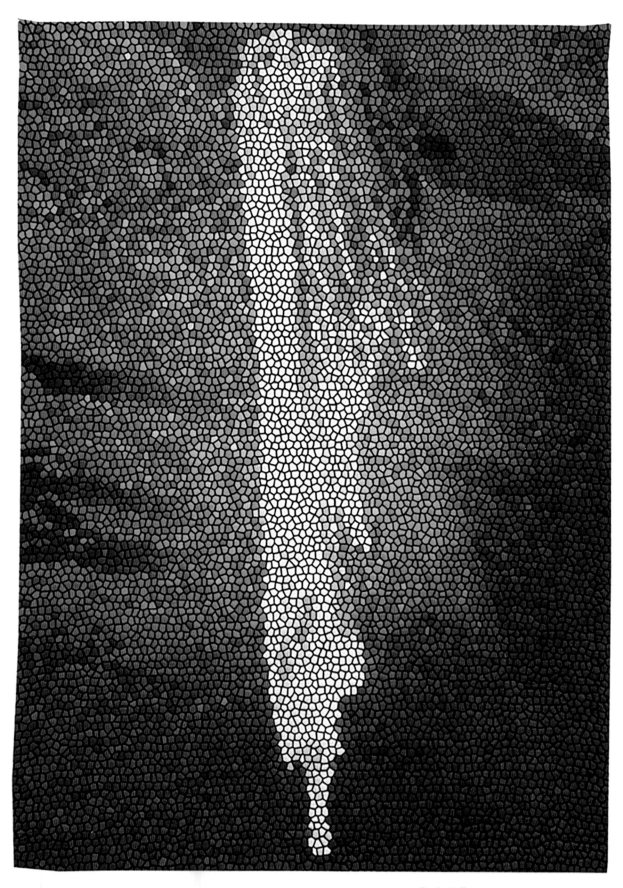

Paula Rafferty
Co. Limerick, Ireland
Tights come Down
42 × 30 inches, 2020

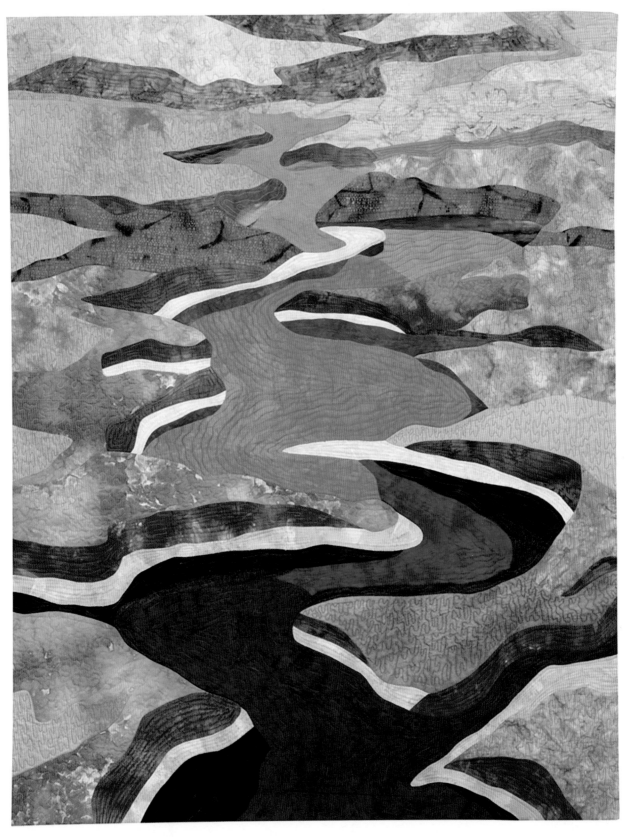

Brenda Smith
Arizona, USA
Glen Canyon 2
42 × 33 inches, 2020

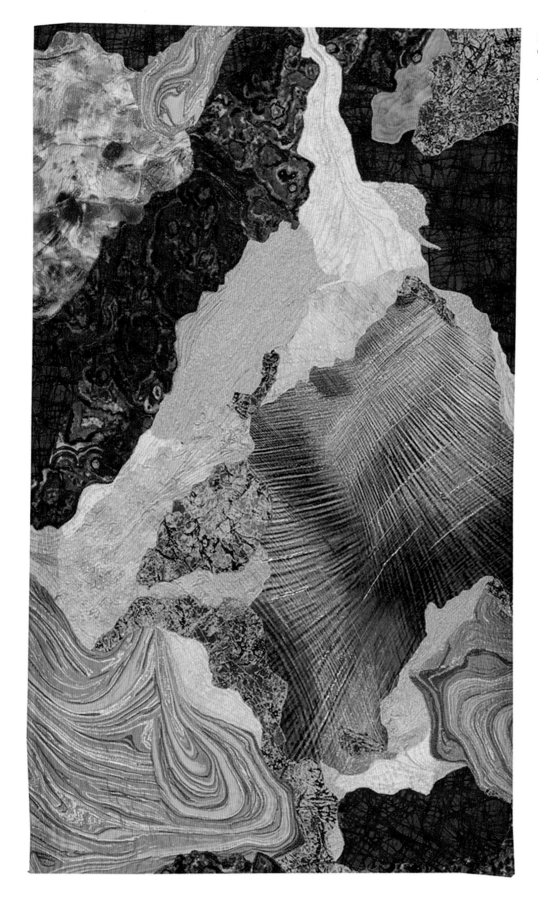

Dorothy G. Raymond
Colorado, USA
Vortex
48 × 29 inches, 2016

An important collection of contemporary quilt art

MEG COX

Nancy Crow
Bittersweet XIV
72 × 71 inches, 1981
Collection of Museum of Arts
and Design, New York,
purchased by the American
Craft Council with funds
provided by a grant from the
National Endowment for the
Arts, 1984. Photo by
Sheldan Comfort Collins.

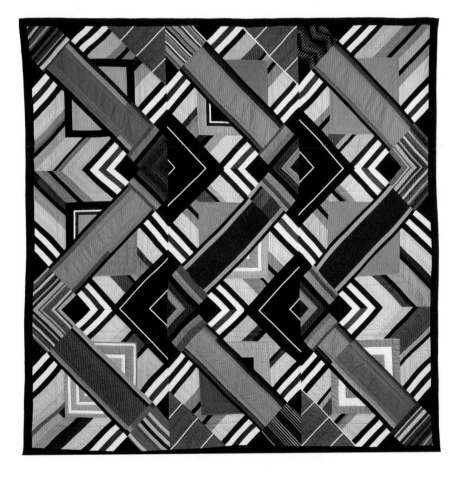

The Museum of Arts and Design (MAD) was founded in New York City in 1956 as the Museum of Contemporary Crafts, with a mission of recognizing the craftsmanship of contemporary artists. Exhibitions focused on the materials and techniques associated with various genres of modern craft, including clay, metal, wood, glass, and fiber. The museum changed names and buildings a few times before landing at its current location, which boasts 54,000 square feet and four floors of gallery space. Over the years, MAD has often been a place for push-the-envelope conceptions of craft. Elissa Auther, the recently appointed collections curator, reports that past exhibitions have featured furs and feathers, personal adornment, and artists who "craft" sound. One exhibition featured bread as a craft.

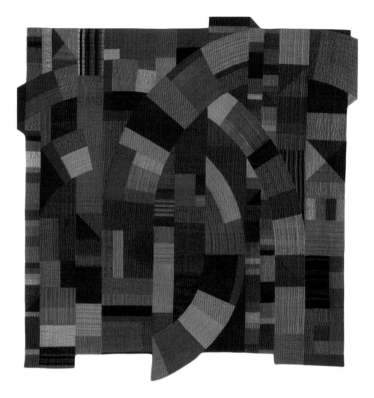

Marilyn Henrion
Byzantium II
66 × 68 inches, 1998
Collection of Museum of Arts
and Design. Photo by Karen Bell.

None of the current curators were working at MAD when the quilt collection was assembled. Jennifer Scanlan spent twelve years at MAD, leaving in 2013 to oversee exhibitions at a contemporary art museum in Oklahoma City. She generously discussed with me how quilts were brought into the collection during her tenure. Scanlan said that the museum generally looked for artists who were at least in midcareer and who had been in exhibitions. She said, "We were looking for an amazing work of art: Does this person have incredible skill? Does this person push the envelope for the craft?"

Scanlan was also present when MAD put together its most significant art quilt show to date, a 2002 exhibition titled *Six Continents of Quilts*, which showcased award-winning quilts from the United States, Japan, Russia, Brazil, India, New Zealand, and Zambia. This popular show premiered outside the museum's walls at an art gallery in the lobby of a nearby skyscraper, the Paine Webber Gallery. Why not hang the quilts at MAD? Scanlan recalls, "The managers of that gallery were always seeking a partnership with us, but much of what we display is three-dimensional and not a good fit for a lobby space. We thought quilts would work because they hang on the walls and because we figured that this show would appeal to a wide audience." *Six Continents* traveled to the Michener Art Museum in Pennsylvania and then on to Tokyo, Japan.

Ursula Ilse-Neuman, the MAD curator who assembled the *Six Continents* show, explains her purpose: "My principal motivation was to raise the image of quilting as an art form that is worldwide in scope (hence the title). In this regard, I was particularly interested in expanding the museum's art quilt collection on a more international scale since the museum had initially concentrated on contemporary American quilts. It certainly is one of the most outstanding collections in America and deserves praise for its great diversity in expression and techniques ranging from narrative to abstraction and from the use of traditional textiles to plastic and even paint."

With a permanent collection of more than 3,000 artworks, most made since the 1950s, only 83 objects are quilts. All but a few of these are art quilts, and the collection as a whole includes some of the most prominent and influential pioneers in the art quilt movement. The first quilt acquired by the museum was Nancy Crow's *Bittersweet XIV*, completed in 1981 and purchased in 1983 with a grant from the National Endowment for the Arts. A second Crow quilt, *Color Blocks 1*, dated 1988, was a gift to the museum from the artist in 1993.

MAD's impressive quilt collection includes three quilts created by groundbreaking artist Michael James and two quilts by Marilyn Henrion. Other works from the 1980s are by Elizabeth Busch, Nancy Erickson, Therese May, Jan Myers-Newbury, and Susan Shie. During the 1990s, MAD acquired art quilts by such significant figures as Judith Content, Michael Cummings, Caryl Bryer Fallert-Gentry, Natasha Kempers-Cullen, Linda MacDonald, Ellen Oppenheimer, Faith Ringgold, Joy Saville, Carol Taylor, and Kathy Weaver.

Only a handful of the quilts at MAD were acquired through the museum's dedicated collection funds or from foundation grants. Of the 83 quilts, slightly more than half were donated by the artists themselves. Most of the rest were given to the museum by collectors.

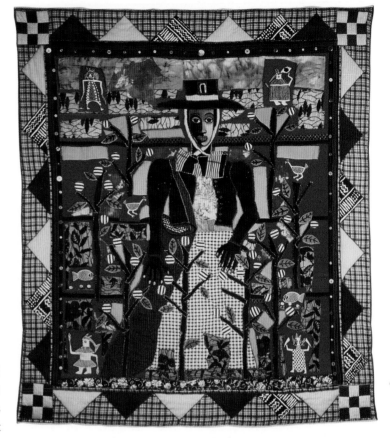

Michael Cummings
I'll Fly Away
90 × 82 inches. 1991
Collection of Museum of Arts and Design. Photo by Karen Bell.

While craft is hot and the Museum of Arts and Design has plenty of fans, it competes with much larger museums in New York City with deeper pockets and more glamorous boards. "I love being here, but it's hard getting attention," Elissa Auther admits. Nonetheless, MAD sits in a prime location, has a reputation for smart shows, and boasts an appealing museum shop with dramatic modern jewelry, handbags, ceramics, and sleekly designed gift items.

Textiles were represented recently with an exhibition by Miriam Schapiro, a pattern and decoration feminist artist known for frequently blurring the lines between art and craft. This exhibition was curated by Auther, who said, "This show focused on her 'femmage' works, collages constructed of cut fabric applied to painted canvas. Many of them directly reference quilt patterns." The exhibition included work by contemporary artists who use decorative, abstract patterning for personal and political purposes. At least one of those artists, Sanford Biggers, incorporates antique quilts into his work.

Shannon Stratton, the museum's chief curator, says, "An important part of our collection plan is to acquire more work in fiber. Going forward for the next five years, that means adding many more contemporary artists working in fiber forms, including the quilt. Quilts will always have a place in MAD's collection."

Power of Nature

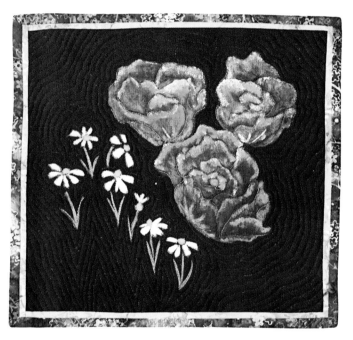

Kay Liggett
Monument, Colorado, USA
ridgewaystudios.org
Night Cabbages
15 × 16 inches (38 × 41 cm), 2018

Maryte Collard
Siauliai, Lithuania
marytequilts.eu
Symphony of Leaves
36 × 37 inches (91 × 93 cm), 2020

Olena K. Nebuchadnezzar
King William, Virginia, USA
olenaarts.com
April Showers
18 × 24 inches (46 × 61 cm), 2020

Cherrie Hampton
Oklahoma City, Oklahoma, USA
Huckleberry Feast
29 × 29 inches (74 × 74 cm), 2017
Photo: Vito Mirrone

Katie Pasquini Masopust
Fortuna, California, USA
Daisies
42 × 35 inches (107 × 89 cm), 2020

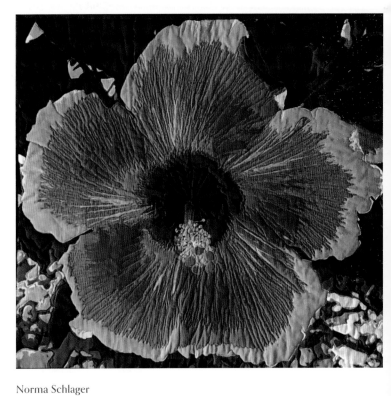

Norma Schlager
Danbury, Connecticut, USA
notesfromnorma.blogspot.com
Radiance
30 × 30 inches (76 × 76 cm), 2020

Phyllis Cullen
Ninole, Hawaii, USA
phylliscullenartstudio.com
We Three I'iwi
60 × 48 inches (152 × 122 cm), 2018
Private collection

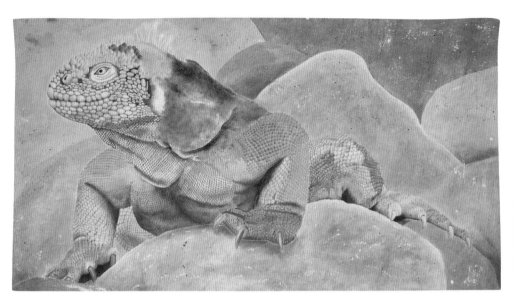

Sue Sherman
Newmarket, Ontario, Canada
sueshermanquilts.com
Galapagos Land Iguana
34 × 63 inches (86 × 160 cm), 2019
Private collection

Cara Gulati
San Rafael, California, USA
caragulati.com
Three Modern Blooms
35 × 31 inches (88 × 77 cm), 2020

Martha E. Ressler
Hamburg, Pennsylvania, USA
martharessler.com
Unmown
40 × 33 inches (102 × 83 cm), 2020
Photo: Jay M. Ressler

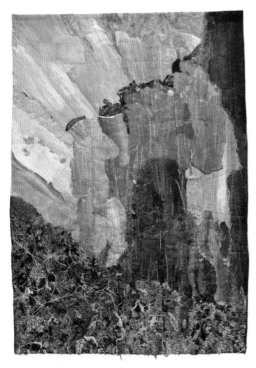

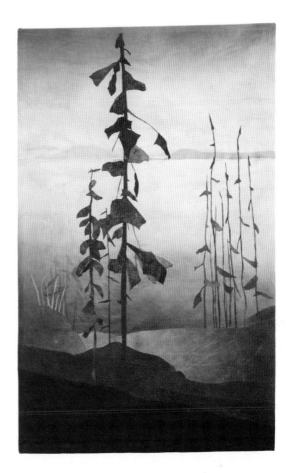

Grietje van der Veen
Therwil, Baselland, Switzerland
textileart.ch
Erosion
33 × 27 inches (83 × 68 cm), 2019
Private collection

Sharon Collins
Arnprior, Ontario, Canada
sharoncollinsart.com
Requiem
40 × 30 inches (102 × 76 cm), 2018
Private collection

Catherine Timm
Westmeath, Ontario, Canada
catherinetimm.com
Tree Bark–An Absolute History of the Passage of Time
#1, 2 & 3
17 × 50 inches, triptych (42 × 127 cm), 2020

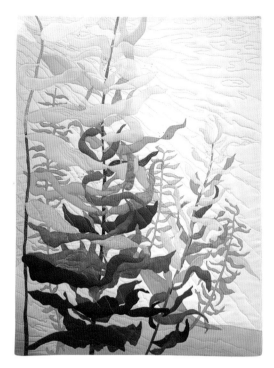

Laura Jaszkowski
Eugene, Oregon, USA
joyincloth.blogspot.com
Kelp Forest
36 × 27 inches (91 × 69 cm), 2020

Karol Kusmaul
Inverness, Florida, USA
kquilt.com
Emerge
40 × 26 inches (102 × 66 cm), 2020

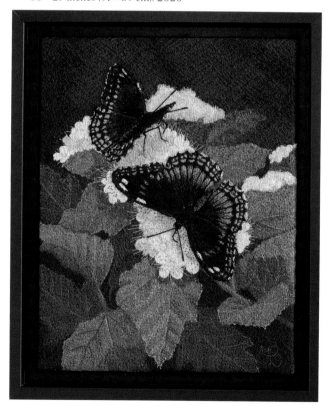

Tracey Lawko
Toronto, Ontario, Canada
traceylawko.com
Red-Spotted Purples
10 × 8 inches (25 × 20 cm), 2018
Photo: Peter Blaiklock

Hsin-Chen Lin
Tainan City, Taiwan, Republic of China
linhsinchen.idv.tw
Please Pour Some Rain!
36 × 24 inches (91 × 61 cm), 2018

Denise Oyama Miller
Fremont, California, USA
deniseoyamamiller.com
Autumn Glow
30 × 41 inches (77 × 103 cm), 2019
Photo: Sibila Savage

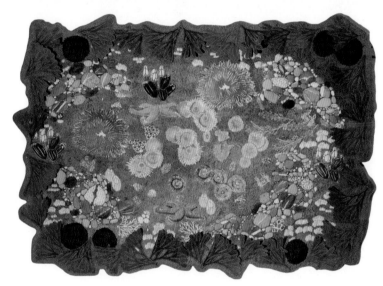

Karen I. Miller
Corvallis, Oregon, USA
nautilus-fiberarts.com
Tidepool Treasures
28 × 40 inches (71 × 102 cm), 2019

Elaine Quehl
Ottawa, Ontario,
Canada
elainequehl.com
Fleur du Soleil
48 × 96 inches (122 ×
244 cm), 2019
Private collection.
Photo: Patrick Blake

Connie Rohman
Los Angeles, California, USA
connierohman.com
Dark Clouds Arising
32 × 52 inches (81 × 132 cm), 2019
Photo: Upgraded Images

Barbara J. Schneider
Woodstock, Illinois, USA
barbaraschneider-artist.com
Line Dance, Tree Ring Patterns, var. 15
52 × 39 inches (132 × 99 cm), 2016

Marianne R. Williamson
Mountain Brook, Alabama, USA
movinthreads.com
Japanese Water Garden
42 × 53 inches (107 × 135 cm), 2020
Photo: Gregory Case Photography

B. J. Adams
Washington, DC, USA
bjadamsart.com
Gathering In
35 × 45 inches (89 × 114 cm), 2018
Photo: Greg Staley Photography

Ilse Anysas-Salkauskas
Cochrane, Alberta, Canada
Following the Sun
29 × 20 inches (72 × 50 cm), 2019

Nancy Bardach
Berkeley, California, USA
nancybardach.com
Tyger in Tall Grass
23 × 34 inches (58 × 86 cm), 2019

Carole Ann Frocillo
Burbank, California, USA
caroleannfrocillo.com
Wispy Day
8 × 8 inches (20 × 20 cm), 2020
Private collection

Sue Benner
Dallas, Texas, USA
suebenner.com
Famous and Not So Famous Flowers #10: Dana's Hydrangeas
30 × 25 inches (76 × 62 cm), 2020
Private collection

Phillida Hargreaves
Kingston, Ontario, Canada
phillidahargreaves.ca
Sea Creature #1
22 × 18 inches (56 × 46 cm), 2020

Janis Doucette
North Reading, Massachusetts, USA
turtlemoonimpressions.wordpress.com
Mingling With the Sacred
12 × 12 inches (30 × 30 cm), 2019

Noriko Endo
Setagaya-ku, Tokyo, Japan
norikoendo.com
Radiant Reflections #3
74 × 69 inches (188 × 175 cm), 2020
Private collection. Photo: Yuji Nomura

Denise Linet
Brunswick, Massachusetts, USA
dlinetart.com
Thorns in My Garden
33 × 46 inches (84 × 117 cm), 2017

Regina Marzlin
Antigonish, Nova Scotia, Canada
reginamarzlin.com
Garden Impressions
24 × 18 inches (61 × 46 cm), 2020

Susan V. Polansky
Lexington, Massachusetts, USA
susanpolansky.com
Shadows of the Divine
32 × 45 inches (81 × 114 cm), 2018
Private collection. Photo: Boston Photo
Imaging

Melody Money
Boulder, Colorado, USA
melodymoney.com
Tall Grass Daydreams
50 × 56 inches (127 × 142 cm), 2020

Alison Muir
Cremorne. NSW, Australia
muirandmuir.com.au
Custodial water
38 × 29 inches (96 × 74 cm), 2019
Photo: Photographix

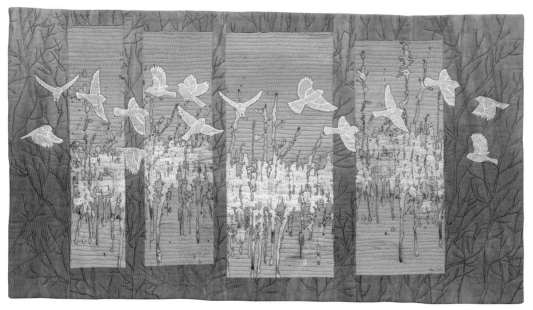

Ree Nancarrow
Fairbanks, Alaska, USA
reenancarrow.com
Winter Redpolls
21 × 39 inches (53 × 98 cm), 2019
Private collection. Photo: Eric Nancarrow

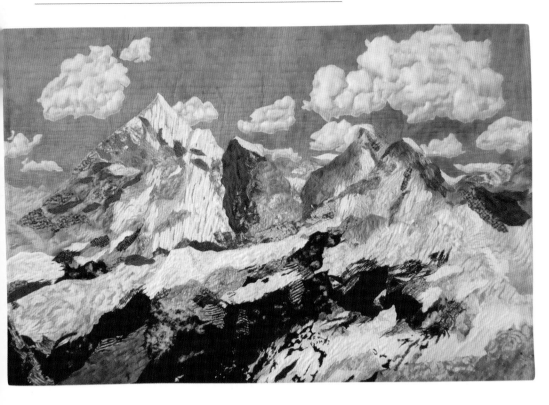

Dorothy G. Raymond
Loveland, Colorado, USA
dorothyraymond.com
Salkatay Mountain
27 × 40 inches (69 × 102 cm), 2019
Private collection. Photo: Allan Snell

Judith Roderick
Placitas, New Mexico, USA
judithroderick.com
Driving to the Purple Mountains Majesty
52 × 40 × 2 inches (132 × 102 × 5 cm), 2020

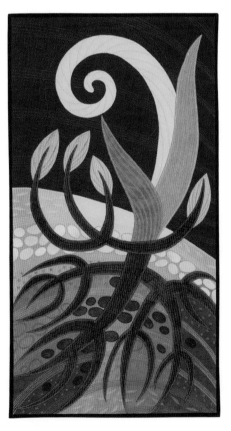

Jane A. Sassaman
Harvard, Illinois, USA
janesassaman.com
Sprout
34 × 19 inches (86 × 47 cm), 2019
Photo: Gregory Gantner

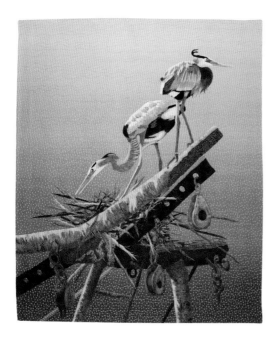

Sara Sharp
Austin, Texas, USA
sarasharp.com
Heron Loft
40 × 34 inches (102 × 86 cm), 2019

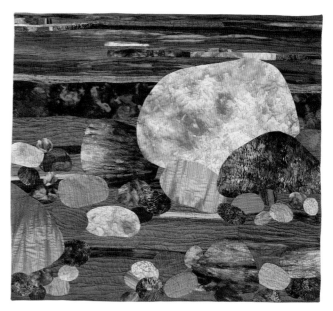

Jean Wells
Sisters, Oregon, USA
jeanwellsquilts.com
Stones Unturned Streams Remembered
40 × 37 inches (100 × 94 cm), 2020
Photo: Paige Vitek

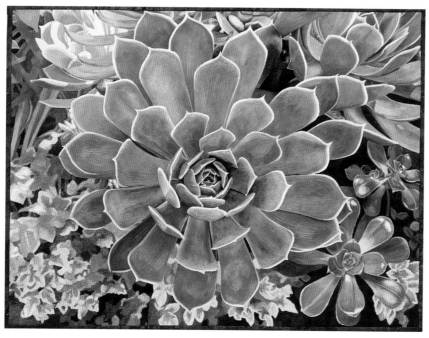

Lenore H. Crawford
Midland, Michigan, USA
lenorecrawford.com
Succulents IV
23 × 32 inches (58 × 81 cm), 2019

Barbara McKie
Lyme, Connecticut, USA
mckieart.com
I Think They Are Watching Us
28 × 28 inches (71 × 71 cm), 2017

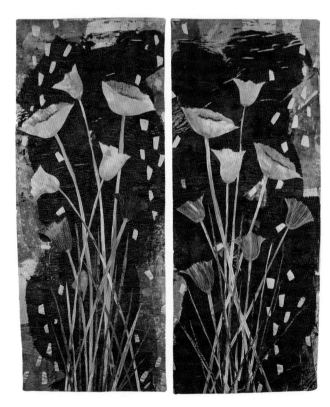

Sarah Lykins Entsminger
Ashburn, Virginia, USA
studioatripplingwaters.com
Eaton Farm Blooms 2
40 × 36 inches (102 × 91 cm), 2020

Pat Bishop

SHAWANO, WISCONSIN

The beginning

When I knew I was going to be a grandma, I realized it was time to use my creativity to develop my own quilts, specifically art quilts. My first one was for my grandson, and it featured frogs leaping into a pond. I had the support of a small group of like-minded people as I became an artist. We challenged each other at monthly gatherings to be original and to try new techniques. Their camaraderie led to the making of my first award-winning art quilts at the Houston International Quilt Festival.

Setting a style

My style is always in flux. I try to portray my message in the simplest terms possible, yet with impact. Simple shapes build the composition. I'm not trying to re-create a photograph, but rather evoke a feeling. My style developed from my love of watercolors and that vagueness where everything is not spelled out. Something new I've been trying out is actually using watercolors on fabric. I previously dabbled in watercolors many moons ago and am hoping to combine the two media. I completed one piece recently with Andrew Wyeth as my inspiration.

I'm not a perfectionist. I don't tie my loose threads on the back of my work; I don't worry about the quilt police. My focus is making art that pleases me. When I am working on a piece, my goal is not to replicate a subject but to simplify it. Things don't have to be perfect to be pleasing; in fact, I feel they are more interesting if they are not.

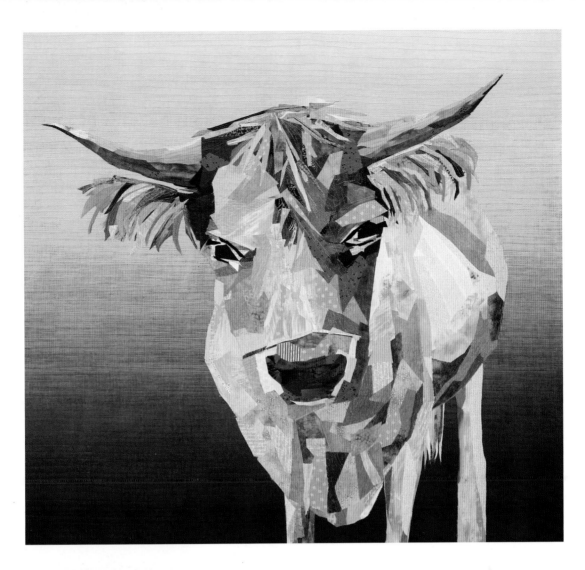

Nutmeg
36 × 40 inches. 2019

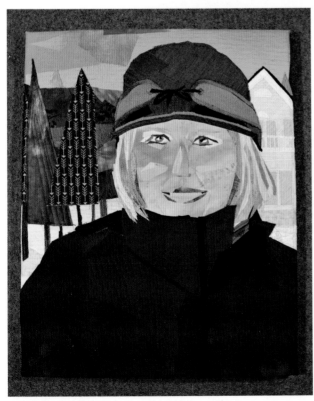

Stormy Kromer Kind of Day (self-portrait)
20 × 16 inches. 2020

Mixing materials

I use textured fabrics that read as solids. These can be linens, silk, cottons, velvet, or whatever I feel works. Other recycled materials I use include paper, birch bark, plastic, or anything that can be sewn. I do not buy much commercial fabric. A lot of what I use is from thrift stores or my own hand-dyed pieces. I love to dye damask, and it is readily available at rummage sales.

I am currently in a fusing mode but still enjoy doing some piecing. When I piece, it's usually very abstract. I love the way I don't know what's going to happen until different fabrics are sewn together. This process feeds my love of problem-solving.

I want my work to read as a painting with texture. I use very fine quilting thread to add texture without bringing much attention to the thread, unless I'm using it for shading or highlighting. I also sometimes use paint to add depth, to tone down, or unify the fabrics.

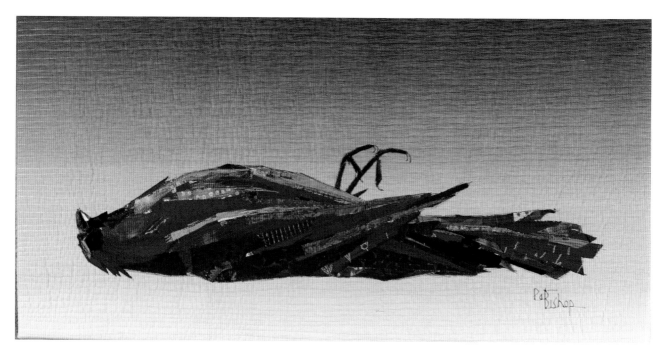

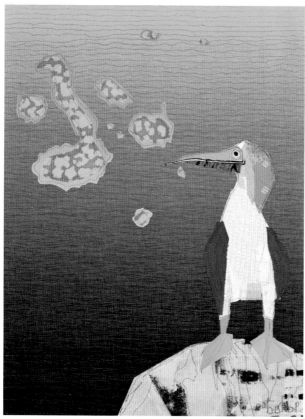

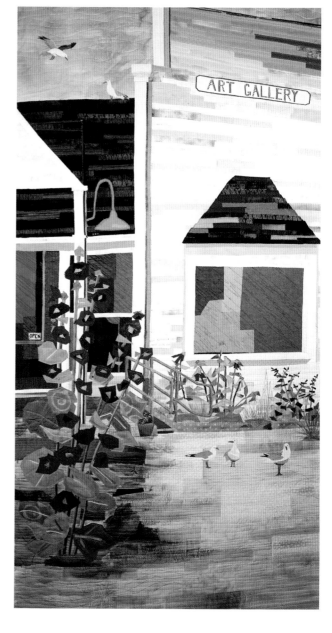

Cardinal Down
15 × 30 inches, 2019

Blue Foot
16 × 12 inches, 2021

Ephraim Shop
70 × 36 inches, 2019

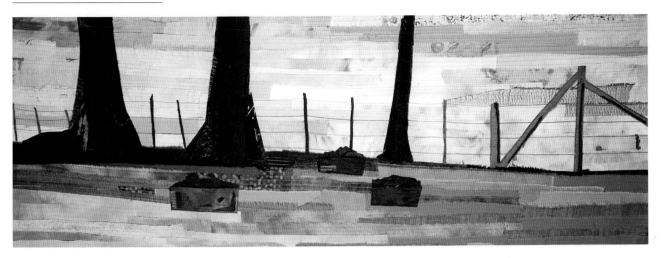

Old Orchard
18 × 50 inches, 2016

Series work

I enjoy working in a series when the subject is something I want to pursue. Sometimes I find I have created a series only after several pieces have been made. My love of birds is the basis for my *Avian* series, which so far includes works of cranes, owls, a crow, and a cardinal. My *She* series was started when I learned to piece abstractly. I loved doing it, and it's a series that I'll probably pick up again. I also do a lot of trees, which is what led to my *Cedar Swamp* series and my apple trees. I do what I love, and that's what can make a series.

Both sets of my grandparents were farmers, and I have an appreciation of the old sheds, barns, and falling-down structures in the Wisconsin countryside. I appreciate their simple beauty, their wabi-sabi imperfection. I know these buildings are quickly disappearing, and I want to preserve their uniqueness. They also lend themselves to my simple abstract technique.

The natural world is usually what inspires me, and it will continue to be an inspiration, especially in this era as we lose precious natural beauty. I hope to do work that inspires others to appreciate all of nature, in an effort to preserve a healthy planet for our children and beyond.

Looking ahead

I hope that my future finds me making more art and continuing my informal art education. The more time I spend in the studio, the more I want to be there. As a SAQA Juried Artist Member and current rep for the SAQA Illinois/Wisconsin region, I expect to become more involved in an organization that has done so much for me. I teach and share my work, and in the coming year I will pursue the one thing left on my bucket list: gallery representation.

www.patbishop.info

Eszter Bornemisza

BUDAPEST, HUNGARY

Organic start

My parents were both scientists. Growing up around an experimental surgeon and a physicist led me to study math, earn a PhD, and become a researcher. That I left a career in science to become an artist at the age of 42 might seem like a radical shift, but for me it was an organic process.

I always liked doing things with my hands–sewing, weaving, shoemaking–all of which I taught myself to do. I have altered and created clothing since I was in my teens, and I enjoy visiting contemporary art exhibitions. In 1996, I visited a contemporary quilt show in France. Suddenly, it clicked–I found something that married my love for art and my interest in sewing. I was completely drawn in and began to make contemporary art quilts. The next year, I entered a piece in the Open European Quilt Championships in Veldhoven, Netherlands, and won Best of Show. This achievement began my textile career, and I am now a full-time studio artist.

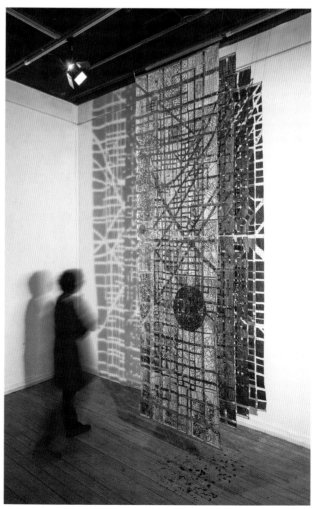

A Matter of Time
83 × 71 inches, 2020
Photo: Irma Horvath

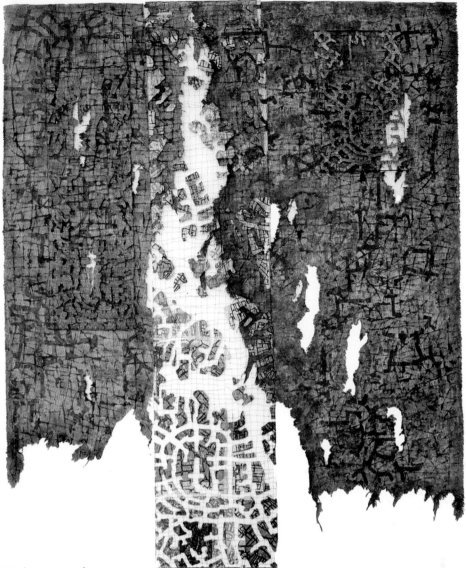

Urban style

Currently I'm exploring the idea of identity. As an urban citizen, my work also revolves around ideas that reflect our relationship to urban life. I use urban layouts in my work, but I go beyond the literal representation of a place to seek out the essence of its environment. With the multilayered surfaces of real and imaginary maps, I grasp the moments when we find our place, physically and mentally.

Today, I mainly use recycled paper in my work, but sometimes I still combine it with textile bits and other found soft materials, such as integrated circuit films from discarded computer keyboards and upcycled yarns. Most of my recent work has been created with newspaper. Its ephemeral character provides further visual experiences. Newspaper is fragile; its content is sometimes obsolete when it appears, yet it bears fragments of important details from our near history. I also use it as a symbol of the overwhelming avalanche of fake and relevant news that we must sift through on a daily basis.

In addition, I like the idea of using recycled textiles to draw attention to the environmental impact of waste. While tons of garments end up in the dump, we maintain the same level of consumption. In some of my work, I have used spoiled x-ray films to emphasize the organic character of the city. Street patterns, depicted as bending grids intersected by curving lines, resemble the organic flow of a biological system.

Left:
Zoom
120 × 36 × 32 inches, 2016
Photo: Tihanyi & Bakos

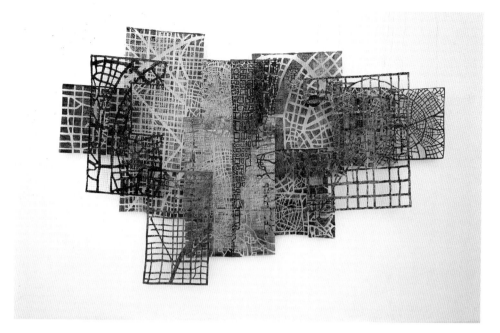

You Are Here
72 × 128 × 16 inches, 2016
Photo: Tihanyi & Bakos

Style and process

I'm a restless explorer, trying to reach beyond successful resolutions to solve challenges I set. I like to investigate new possibilities, and the theme of my work evolves through this process.

When I started quilting, I pieced Log Cabin blocks. Soon I shifted to textile collage because it gave me more freedom to develop ideas and composition. Then maps became a visual inspiration, and I incorporated fragmented, cutout street plans. The plans led me to think more deeply about urban existence and how we cope with the many changes that happen where we live. Using city maps in different ways has allowed a flow of inspiration to spark new themes and ideas. My first work with maps was in 2001, so these pieces form a very long series.

Technical challenges that I faced translating my ideas into a visual language led me to create transparent pieces. This solution gave me more freedom to develop even more new ideas.

When a piece isn't working well, I put it aside. When I feel that a piece is not coming out as I wished, it is a sign that the idea was not clear enough, and/or the materials don't match it up, so it needs some time to mature. It can be a few weeks, but sometimes years. Working and contemplating on other pieces bring the solution sometimes.

Viewer experience

I hope that viewing my work evokes personal experiences of getting lost, that viewers try to find points of reference and balance on the edge of insecurity. We each possess and create intimate places through our own patterns of movement; our patterns spin out from where we live and work. Even our well-known safe patterns may come undone when confronted with unexpected circumstances. As we get into unfamiliar territories, vagueness increases. Individual segments of memory and experience that get embedded within the larger urban context are what I hope people will recognize and remember seeing in my work.

Right:
Requiem
80 × 40 × 28 inches, 2014
Photo: Tihanyi & Bakos

Strata
35 × 20 inches, 2021
Photo: Irma Horvath

Waste-Borough
110 × 60 × 4 inches, 2019
Photo: Tihanyi & Bakos

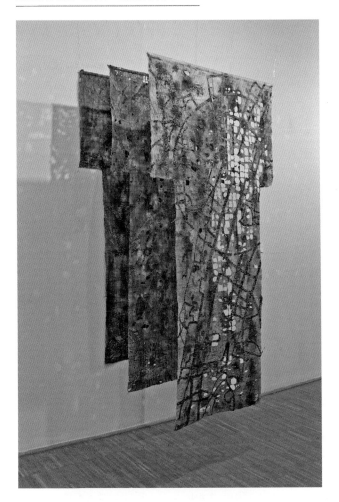

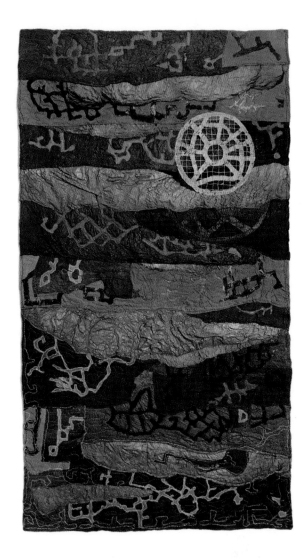

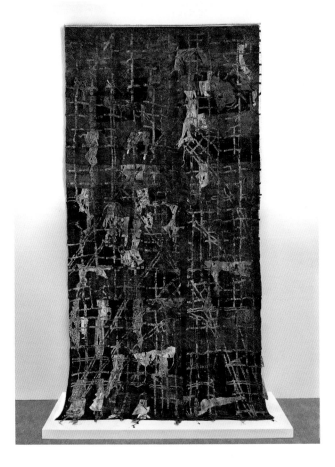

Future plans

I am upcycling some old quilts of mine, experimenting with creating several 3-D shapes for an installation. Also, I got invited to create another installation project in a 13th-century church in France. It will include locally produced paper, and I will be applying earlier work. It's a great challenge, and I'm very much looking forward to it.

My piece *A Matter of Time* won the main prize at the Art Textile Biennale Australia. I'm very happy with this. As a consequence, there was a long online interview with me posted on the Fibre Arts Take Two site.

bornemisza.com

The California Art Quilt Revolution

NANCY BAVOR, EXECUTIVE DIRECTOR

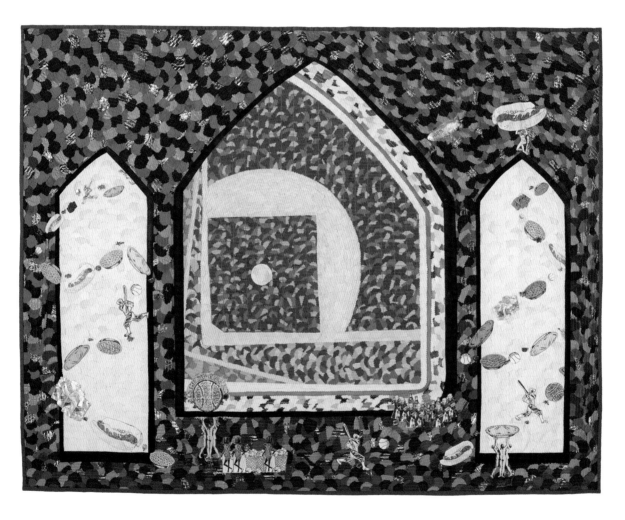

Holley Junker
Baseball: As American as Apple Pie and Quilts
39 × 59 inches, ca. 1990
Collection of San Jose Museum of Quilts & Textiles.
Gift of Yvonne Porcella. Photo by James Dewrance.

Therese May
Therese at the Kitchen Sink
79 × 89 inches, 1977
Collection of San Jose Museum
of Quilts & Textiles. Gift of the
artist. Photo by James Dewrance.

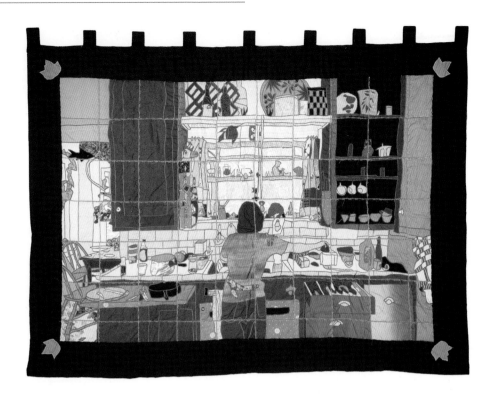

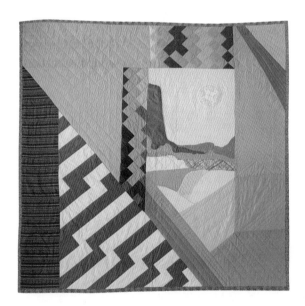

Joan Schulze
Where Dreams are Born
90 × 90 inches, 1976
Collection of San Jose Museum of Quilts & Textiles.
Gift of the artist.

San Jose Museum of Quilts & Textiles traced the history of the California art quilt movement in *The California Art Quilt Revolutions: From the Summer of Love to the New Millennium.* The exhibition included works by art quilt pioneers Jean Ray Laury, Yvonne Porcella, Miriam Nathan-Roberts, Ellen Oppenheimer, Joan Schulze, and Therese May, as well as work by Judith Content, Linda Gass, Joe Cunningham, Alice Beasley, Dan Olfe, Robert Leathers, Pixeladies, and Susan Else.

The first of three galleries displayed works from the 1970s and 1980s.

In *Baseball: As American as Apple Pie and Quilts,* Holley Junker uses her innovative pointillist technique—small pieces of pinked or frayed fabrics, layered and stitched—to create a feast of color, depth, texture, and theme. The artist's humorous depiction of American icons is, in the artist's words, an "investigation of light and texture."

In the mid-1970s, Joan Schulze made several California landscape-inspired quilts, including *Where Dreams are Born,* which references traditional quilt blocks but visually and metaphorically looks beyond the patterned foreground to an impressionistic California vista. Like many quilts from this time, it illustrates the artist's urge to apply new designs and

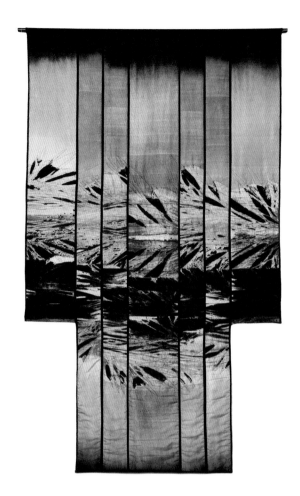

Judith Content
Tempest
87 × 51 inches, 2000
Collection of San Jose Museum of Quilts & Textiles. Gift
of Paul Robbins. Photo by James Dewrance.

techniques while still honoring traditional quilt patterns.

During the late 1960s and 1970s, Therese May combined her love of photography and collage to create numerous figurative works out of material purchased at secondhand stores. Her subject matter focused on domestic scenes, her children, and her collection of salt-and-pepper shakers. *Therese at the Kitchen Sink* is one of a series she made in 1977, using herself and friends as subjects, performing the familiar task of washing dishes.

The second gallery featured later work by the art quilt pioneers, illustrating how their styles evolved and matured, and also displayed work artists who were emerging at the time.

Although created in 2000, Judith Content's *Tempest* is representative of the distinctive style she developed in the 1980s. The artist assembles her silk-discharged and self-dyed panels into kimono shapes intended for wall display. While completely nonrepresentational, this work encourages the viewer to consider the late-winter Pacific Ocean storm sweeping onto the shore, and the resulting sea tempest that inspired the work.

With *Spin Cycle*, Miriam Nathan-Roberts continues her exploration of three-dimensional imagery, incorporating airbrushed highlights and shadows to heighten the 3-D effect.

Works in the third gallery explored a wide range of subject matter using a variety of materials and techniques. Fabrics were silk-screened, hand-dyed, painted, repurposed, found, commercial, and digitally printed. Artists continue to explore new technology such as digital photography and software to create or manipulate images.

Like contemporary artists working in other media, artists working in the 21st century use the quilt format to address important social, political, economic, and environmental issues. Whether the works are by artists who have spent decades working in the quilt medium, or have been created by artists who

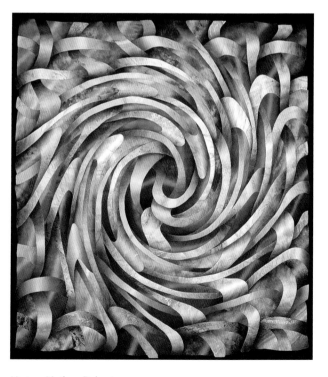

Miriam Nathan-Roberts
Spin Cycle
71 × 66 inches, 1998

Right:
Joe Cunningham
Autoworld
72 × 72 inches, 2015

Bottom right:
Alice Beasley
No Hard Hats Required
70 × 48 inches, 2012

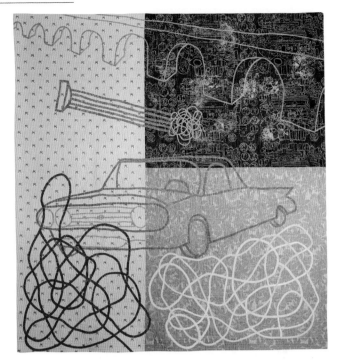

embraced the art form more recently, global issues are at the forefront of subject matter.

Joe Cunningham's *Autoworld* conflates two decaying cities the artist visited in the summer of 2015—Flint, Michigan, and Rome, Italy. He juxtaposes an image of a big American car with the Roman Aqueduct and a fallen Doric column. Images of Roman coins and V-8 engines are machine-quilted throughout the piece.

Alice Beasley's *No Hard Hats Required* from her series *The Game is Rigged* addresses one of the effects of the global financial crisis that began in 2008. The artist's poignant depiction of a worker fenced out of employment reminds us of the individual toll that resulted from international financial mismanagement.

Contemporary quilt artists continue to push boundaries of what can be considered a quilt, embracing new materials and techniques, and some of them create work in three dimensions. Like the pioneers of the art quilt movement, they continue to explore what is considered a quilt and blur the lines between fine art and craft.

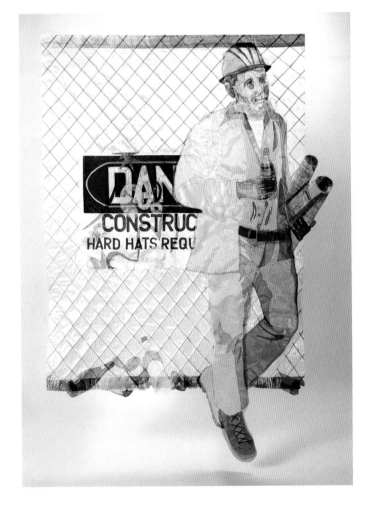

Tactile & Textural

Harriet Cherry Cheney
Dobbs Ferry, New York, USA
harrietcheney.com
Many Little Suns
40 × 23 × 2.5 inches (102 × 57
× 6.4 cm), 2019
Photo: George Potanovic, Jr.

Shannon M. Conley
Moore, Oklahoma, USA
shannonconleyartquilts.com
33°20'N, 105°33'W
64 × 34 × 6 inches (163 × 86 × 15.2 cm), 2018
Photo: Mike Cox

Sandra E. Lauterbach
Los Angeles, California, USA
sandralauterbach.com
Lyrical
30 × 46 inches (76 × 116 cm), 2019

Cathy Erickson
Washougal, Washington, USA
cathyericksonquilts.com
Laurel Leaf
52 × 52 inches (132 × 132 cm), 2018

Mita Giacomini
Dundas, Ontario, Canada
mitagiacomini.com
Colour Theories
26 × 26 inches (66 × 66 cm), 2019

Mary Lou Alexander
Hubbard, Ohio, USA
Maryloualexander.net
New Growth
19 × 19 × 3 inches (48 × 48 × 7.6 cm), 2019
Private collection. Photo: Joseph Rudinec

Mary B. Pal
Toronto, Ontario, Canada
marypaldesigns.com
Bella
60 × 36 inches (152 × 91 cm), 2020
Private collection. Photo: Thomas Blanchard

Miki Rodriguez
San Antonio, Texas, USA
mikirodriguez.com
Airborne
85 × 41 inches (216 × 104 cm), 2020

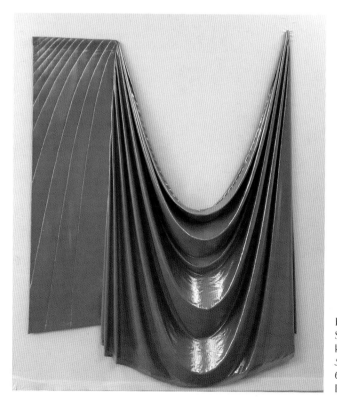

Sharon McCartney
Belchertown, Massachusetts, USA
sharonmccartneyart.com
Details of the Journey
50 × 7 × 2.25 inches (127 × 18 × 5.7 cm), 2018
Photo: John Polak Photography

Katriina Flensburg
Storvreta, Sweden
katriinaflensburg.se
Serenity
69 × 53 × 10 inches (175 × 135 × 25.4 cm), 2019
Private collection

Susan Else
Santa Cruz, California, USA
susanelse.com
Inheritance
8 × 11 × 11 inches (20 × 28 × 27.9 cm), 2020
Photo: Marty McGillivray

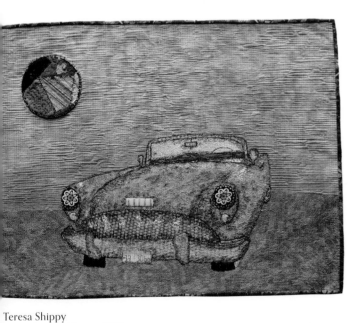

Teresa Shippy
Santa Ana, California, USA
teresashippy.com
54 Buick Skylark Convertible
25 × 30 inches (62 × 76 cm), 2018
Private collection

Sylvia Weir
Beaumont, Texas, USA
sylviaweirart.wordpress.com
Rock Wall
20 × 30 inches (51 × 76 cm), 2019

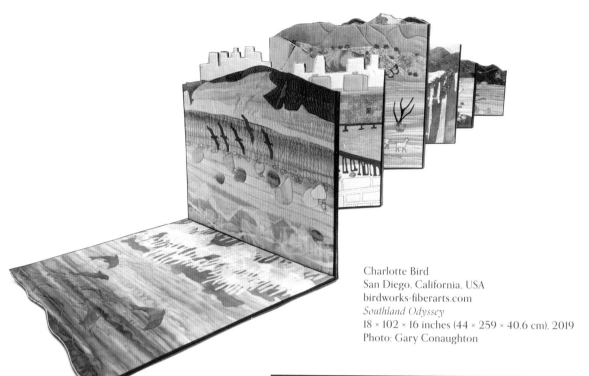

Charlotte Bird
San Diego, California, USA
birdworks-fiberarts.com
Southland Odyssey
18 × 102 × 16 inches (44 × 259 × 40.6 cm), 2019
Photo: Gary Conaughton

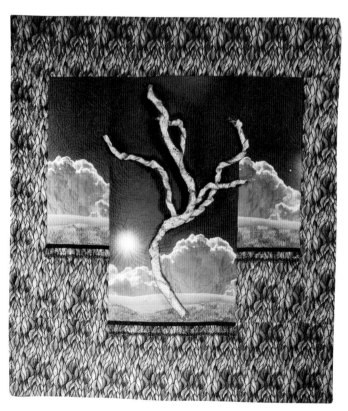

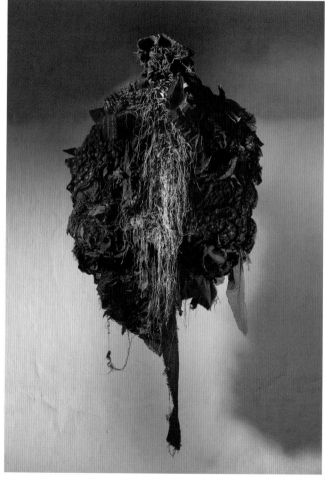

Mary Beth Bellah
Charlottesville, Virginia, USA
marybethbellah.com
Respite Under a Blue Sky
44 × 39 × 3.5 inches (112 × 99 × 8.9 cm), 2019

Chiaki Dosho
Kawasaki-shi, Kanagawa-ken, Japan
chiakidoshoart.com
Cocoon 2
47 × 40 × 6 inches (119 × 102 × 15.2 cm), 2013
Private collection. Photo: Akinori Miyashita

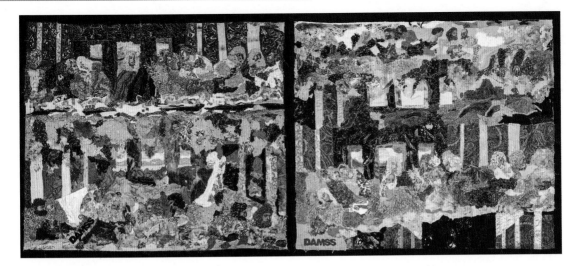

Daniela e Marco Sarzi-Santori (DAMSS)
Milano, Italy
damss.com
pop supper series 102-103
59 × 118 inches (150 × 300 cm), 2019
Private collection

Jennifer Day
Santa Fe, New Mexico, USA
jdaydesign.com
1952 Buick Chieftain
26 × 24 inches (66 × 61 cm), 2018

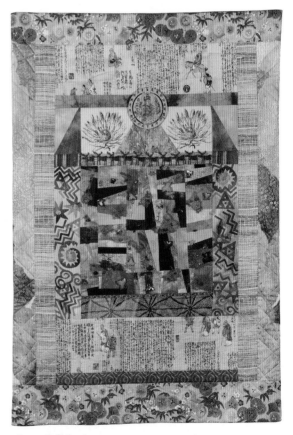

Susan Ball Faeder
Lewisburg, Pennsylvania, USA
qejapan.com
the sacred combs of empress Jingu (169-269 CE)
47 × 32 inches (118 × 81 cm), 2020
Photo: Gordon Wenzel

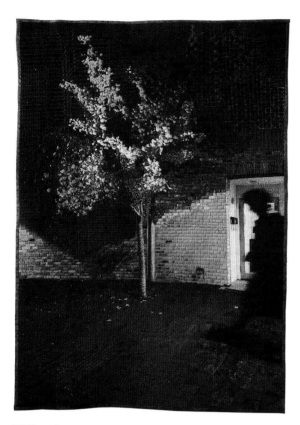

Jill Kerttula
Charlottesville, Virginia, USA
jillkerttula.com
Ginkgo
54 × 39 inches (137 × 99 cm), 2019

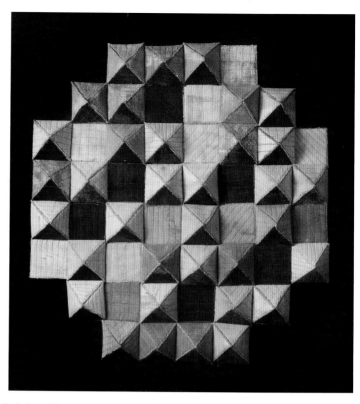

Judy Langille
Kendall Park, New Jersey, USA
judylangille.com
Facade 5
32 × 32 × 4 inches (81 × 81 × 10.2 cm), 2019
Photo: Peter Jacobs

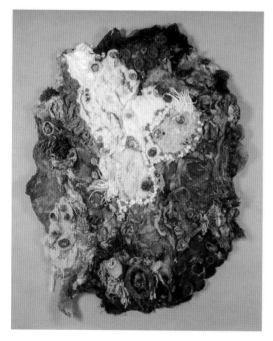

Jean Sredl
Shawano, Wisconsin, USA
sredl.com
Coral Sea
64 × 45 × 12 inches (163 × 114 × 30.5 cm), 2018
Photo: Steve Ryan Photography

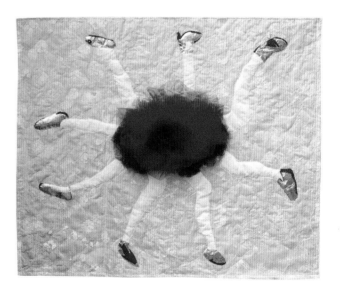

Tiziana Tateo
Vigevano, Pavia, Italy
tizianatateo.com
Lost in Lace
50 × 60 inches (127 × 152 cm), 2019

Marty Ornish
La Mesa, California, USA
marty-o.com
She gazed at the carousel through rose-colored glasses.
67 × 49 × 57 inches (170 × 124 × 144.8 cm), 2020
Photo: Steven Ornish

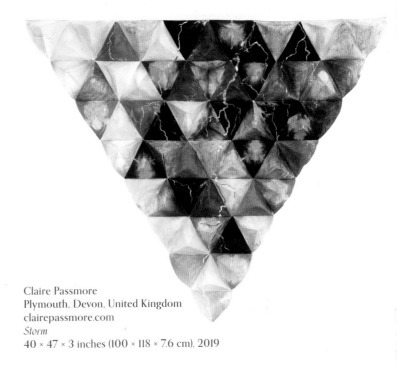

Claire Passmore
Plymouth, Devon, United Kingdom
clairepassmore.com
Storm
40 × 47 × 3 inches (100 × 118 × 7.6 cm), 2019

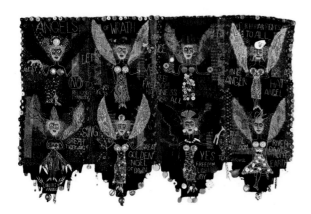

Ulva Ugerup
Malmö, Sweden
Angels of Wrath
29 × 43 inches (74 × 109 cm), 2008
Photo: Deidre Adams

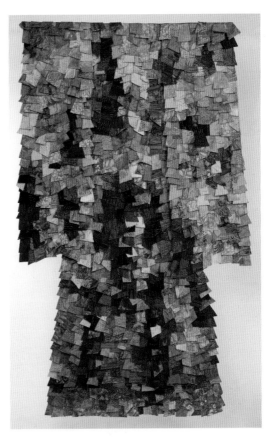

Judith Tomlinson Trager
Portland, Oregon, USA
judithtrager.com
Forest Guardian
84 × 42 × 2 inches (213 × 107 × 5.1 cm), 2016
Photo: Ken Sanville

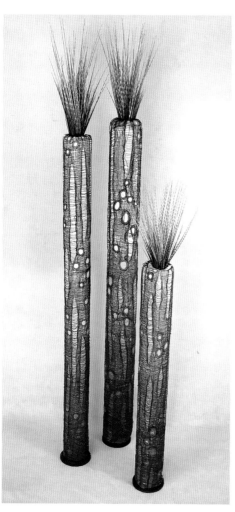

Betty Busby
Albuquerque, New Mexico, USA
bbusbyarts.com
Sentinel
90 × 20 × 15 inches (229 × 51 × 38 cm), 2020

Elena Stokes
Clinton, New Jersey, USA
elenastokes.com
Solaris
76 × 32 inches (193 × 81 cm), 2018

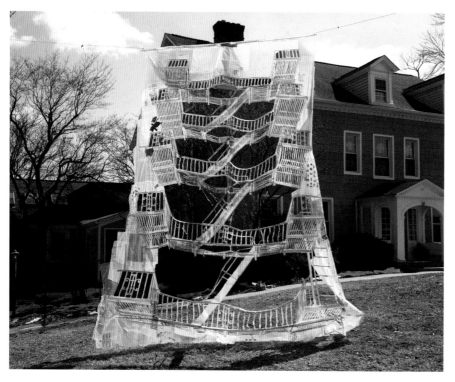

Natalya Khorover
Pleasantville, New York, USA
artbynatalya.com
Iron Spine Aloft
204 × 204 inches (518 × 518 cm), 2019
Photo: Rob Koch

Barbara Oliver Hartman
Flower Mound, Texas, USA
barbaraoliverhartman.com
Help: Blood and Chaos
45 × 55 inches (114 × 140 cm), 2018
Photo: Sue Benner

Rosemary Claus-Gray
Columbia, Missouri, USA
rosemaryclaus-gray.com
Journey
26 × 26 inches (66 × 66 cm), 2019
private collection

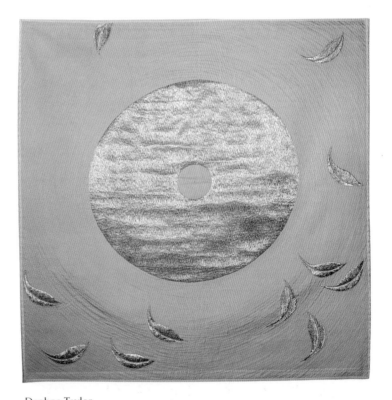

Maya Schonenberger
Miami, Florida, USA
mayaschonenberger.com
Orinoco Flow
32 × 14 inches (81 × 36 cm), 2019
Private collection. Photo: Werner Boeglin

Daphne Taylor
Montville, Maine, USA
daphnetaylorquilts.com
Quilt Drawing №23
40 × 40 inches (102 × 102 cm), 2019
Photo: Kevin Johnson

Regina V. Benson
Golden, Colorado, USA
reginabenson.com
A River Ran Here
37 × 54 × 8 inches (94 × 137 × 20 cm), 2017
Photo: John Bonath

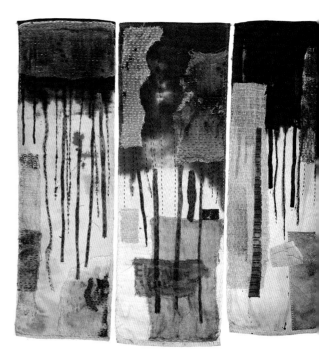

Jette Clover
Lier, Antwerpen, Belgium
jetteclover.com
Cry Me a River
29 × 28 inches (74 × 72 cm), 2019
Private collection. Photo: Pol Leemans

Fenella Davies
Frome, Somerset, United Kingdom
fenelladavies.com
Death in Venezie
45 × 36 inches (115 × 91 cm), 2014

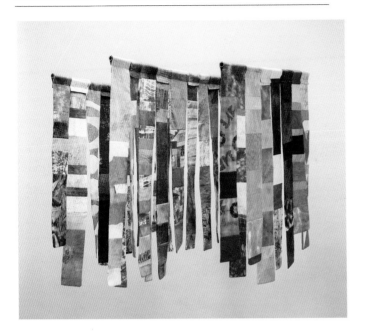

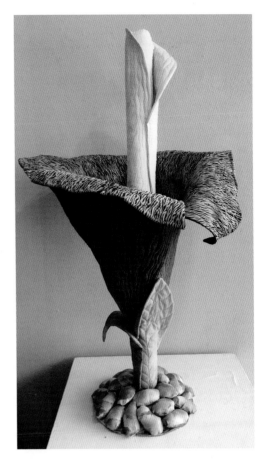

Giny Dixon
Danville, California, USA
ginydixon.com
Segments of Diversity
38 × 52 × 36 inches (97 × 132 × 91.4 cm), 2019
Photo: Sibila Savage

Marjan Kluepfel
Davis, California, USA
marjankluepfel.com
Titan Arum
41 × 25 × 25 inches (104 × 64 × 64 cm), 2018
Private collection

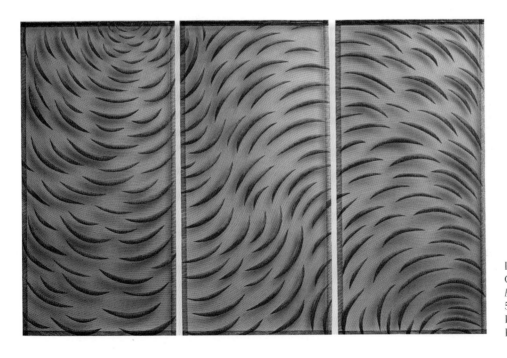

Dianne Firth
Canberra, ACT, Australia
Blown by the Wind
53 × 81 inches (135 × 206 cm), 2020
Private collection.
Photo: Andrew Sikorski

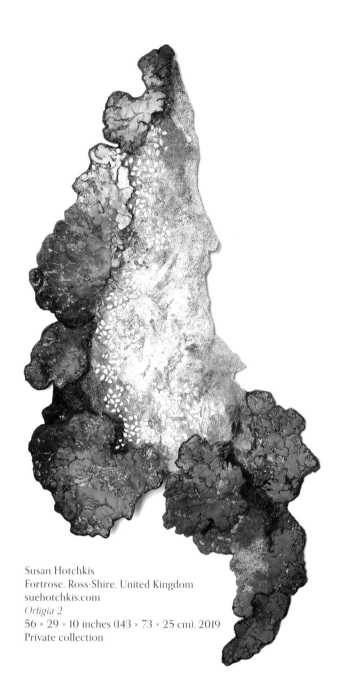

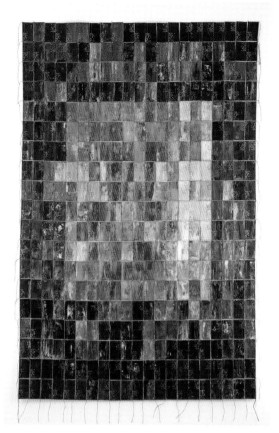

Judith Mundwiler
Sissach, Switzerland
judithmundwiler.ch
PINK!
65 × 42 inches (165 × 106 cm), 2018
Private collection. Photo: David Spinnler

Susan Hotchkis
Fortrose, Ross-Shire, United Kingdom
suehotchkis.com
Ortigia-2
56 × 29 × 10 inches (143 × 73 × 25 cm), 2019
Private collection

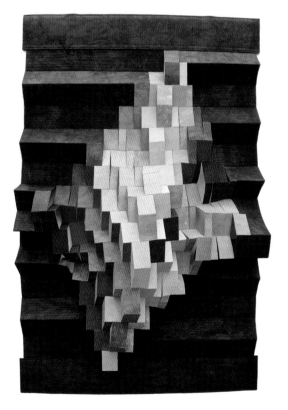

Diane Nunez
Southfield, Michigan, USA
dianenunez.com
Spaces
51 × 33 × 10 inches (130 × 84 × 25 cm), 2015
Corporate collection. Photo: Rion Nunez

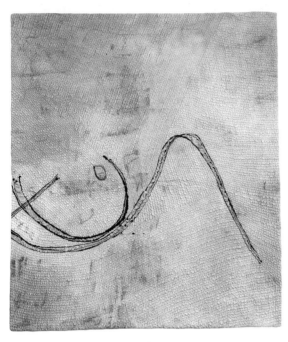

Karen Rips
Thousand Oaks, California, USA
karenrips.com
Heartbroken #3
42 × 37 inches (107 × 94 cm), 2019
Photo: Ted Rips

Helena Scheffer
Beaconsfield, Quebec, Canada
helenascheffer.ca
Temperature Rising
36 × 36 inches (91 × 91 cm), 2019
Photo: Maria Korab-Laskowska

Brigitte Kopp
Kasel-Golzig, Germany
brigitte-kopp-textilkunst.eu
Diving into thoughts
36 × 59 × 0.5 inches (90 × 150 × 1.3 cm), 2019

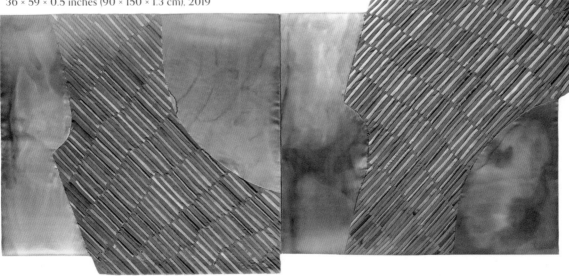

Shin-hee Chin

MCPHERSON, KANSAS

Art quilt discovery

I began my art career in Korea creating surface design works and oil paintings. As a graduate student in California in 1995, I made fiber sculptures out of old clothes and weaving thrums [loom waste threads] incorporating stitches into my work. My graduate show featured recycled materials to address the historically confined role of women in the home. In 2002, a different opportunity presented itself. My 90-year-old neighbor gave me a box of scraps that I made into yo-yos. From those yo-yos, I constructed a self-portrait – my first art quilt.

Since 2004, I have taught at Tabor College in Kansas. While my teaching schedule interrupted my personal work, I found time to make approximately 22,000 yo-yos. In 2008, I had a solo exhibition titled *Human Family* as part of Tabor College's centennial. My body of work consisted of 15 art quilts made from yo-yo quilt blocks.

Gender conversations

Christian faith and feminist ideas on gender equality challenge me to seek an art space where the voices of effaced and silenced women can reverberate. I translate experiences common to women into artwork, making them accessible to people from different ethnic backgrounds and giving viewers a way to sympathize. I convert the conventional "feminine" activity of needlework into a useful medium for making art. The process of arbitrary wrapping and stitching – similar to the tedious, repetitive activities that preoccupy women at home – enables me to call on the creative potential that lies within devalued labor performed by women.

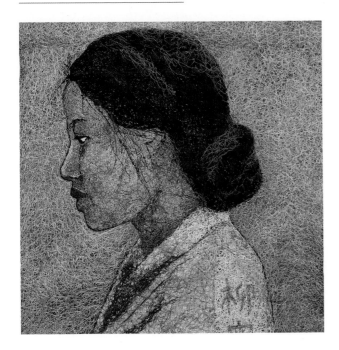

My various ongoing series explore humanity and dignity in human beings and highlight our inter-connectedness. I also have a series that depicts marginalized people who are voiceless, faceless, and nameless. My work acknowledges the trials endured by victims and minorities. Along with my focus on humanity, I explore text and image, language and identity, landscape and environment.

Materials, techniques combine

The common threads that connect all of my work are the materials and techniques used for quilt making. I appropriate and valorize craft techniques such as stitching, random wrapping, basketry, and binding. Techniques hold great meaning for me as a compositional device. In experimenting with a variety of domestic media, such as clothes, threads, and paper, my hands participate in the process of intricate linking of the irregular pattern of threads. The slow, repetitive nature of stitching enables me to be more mindful of the present moment.

When I discovered the great potential of thread as an art medium, I used recycled thrums from the weaving loom and developed my random-weave-and-stitch method. Applying this method, I have been creating a series of representational and abstract fiber quilts. These works are constructed by unraveling threads of similar shades or complementary colors and randomly stitching them down by hand.

Above left:
Ryu, Gwan-Sun
40 × 40 inches, 2013
Photo: Jim Turner

Above right:
A Call to Harvest
169 × 74 inches, 2019
Collection of Shari Flaming Center for the Arts at Tabor College, Kansas. Photo: Jim Turner.

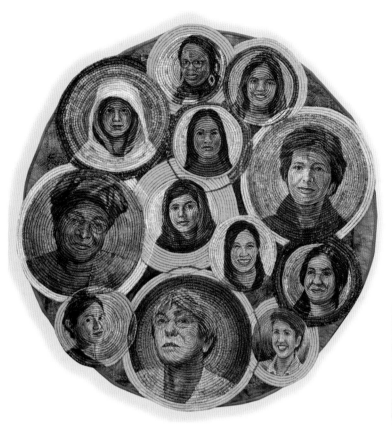

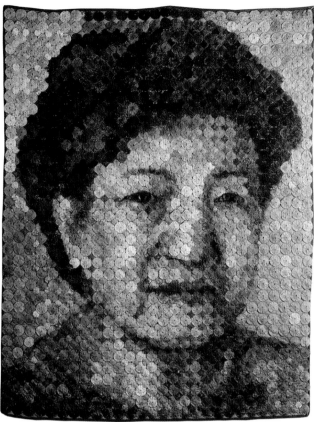

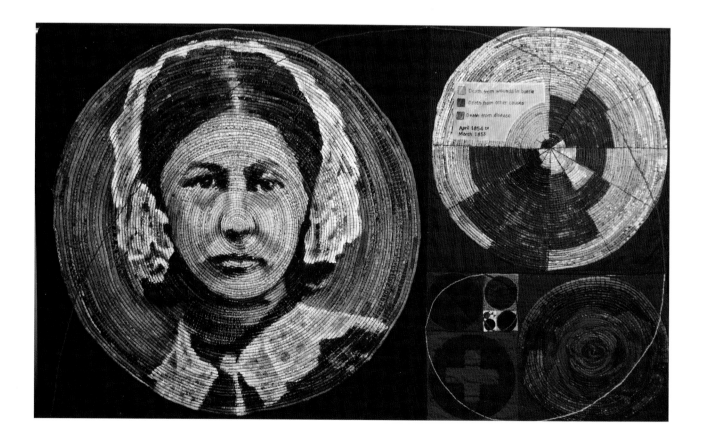

Left, clockwise from top left:

The Future Is Female: 12 Female Humanitarians (Ellen Johnson Sirleaf, Michelle Bachelet, Mary Robinson, Greta Thunberg, Melanie Chiponda, Xiye Bastida, Autumn Peltier, Malala Yousafzai, Joyce Tan, Elisa Palazzi, Farwiza Farhan, and Nadia Murad)
52.5 × 52 inches, 2020
Photo: Jim Turner

Choonsan Spring Mountain
60 × 48 inches, 2008
Photo: Jim Turner

Florence Nightingale
48 × 78 inches, 2013
Photo: Jim Turner

I developed my coiling technique by appropriating a traditional Korean paper-twisting method called ji-seung, which literally means paper cord, used for basket weaving. I substitute recycled fabric for rice paper to construct fabric tubes. Then I connect the tubes with blanket stitching. I dye some of the strips to achieve the desired tonal quality.

I have tried to incorporate various elements of art making, such as conventional Asian art- and craft-making skills and oil painting, into my work. People are often surprised to see how the style and message of my works are intricately intertwined with each other. In most of my art works, medium is a message: I strategically use media that have been traditionally associated with the feminine. Like many feminist artists, I utilize needle, thread, and fabric in order to call into question the deep-seated bias that women's works are trivial, menial, and marginal. I have constantly experimented with various methods, which led to the emergence of new techniques such as "yo-yo portrait quilt," "random weave and stitches," "fabric coiling," and "abstract mixed media collage."

What's next

Currently I am working on two projects simultaneously: The first project, *Splendor in the Grass*, is a commissioned work for the School of Medicine–Salina Campus, University of Kansas. It sets out to explore the beauty of prairie grasses, highlighting cultural and aesthetic roots of rural Kansas. The work is imbuing the landscape with a "spirit of resonance" or vitality. Through this imagery, I wish to represent KUSM-S's [KU School of Medicine–Salina] unique cultural heritage and its vision for the future as an educational institution for excellent medical service professionals in rural Kansas and the surrounding area.

The second project, *Embracing the Void: Winds-scape in Flint Hills*, is intended to visualize the symbiotic relationship between nature and human beings through the outdoor installation in the natural setting. The project has been inspired by the concept of psithurism, literally meaning the sound of wind whispering through the trees, symbolizing the intimate dialogues between human and nature.

Utilizing cotton, linen, and polyester threads, I will connect numerous existing trees in the site, envisioning the ideal and harmonious coexistence of human beings and their surrounding environment. Here, the artificial structures/nets will serve as an interpreter, translator, or catcher of the sound of wind in the trees and enable us to embrace the mysterious and restorative force in nature.

www.shinheechin.com

Fenella Davies

BATH, NORTH SOMERSET, UNITED KINGDOM

History as inspiration

History and reading have always been hugely important for me: who we are, from where we come, the marks that have been left by people before us. Travels to ancient sites and historical places – Greece, Venice, Italy, and Turkey – really inspire me. Wandering around old gravestones allows me to trace our history.

Bath, England, is a Georgian town where many houses and terraces date back to the 1700s. My studio is in our rambling cottage, built circa 1780, with old beams and stonework. I sometimes look with envy at the wonderful purpose-built studios that some modern artists have, but know that I need to be surrounded by history in order to work.

My work has always been connected to the past. Each time I visit Venice, I see traces of the beauty that was. You can sketch out the lives of the Venetians from hundreds of years ago to today through empty dark passageways, sounds of feet on the stones, and echoes of times past. All of this is now rapidly fading with pollution and time, but you can still feel the emotion of connection.

Horizon
18.5 × 90 inches. 2017

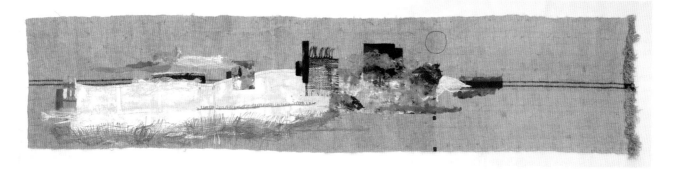

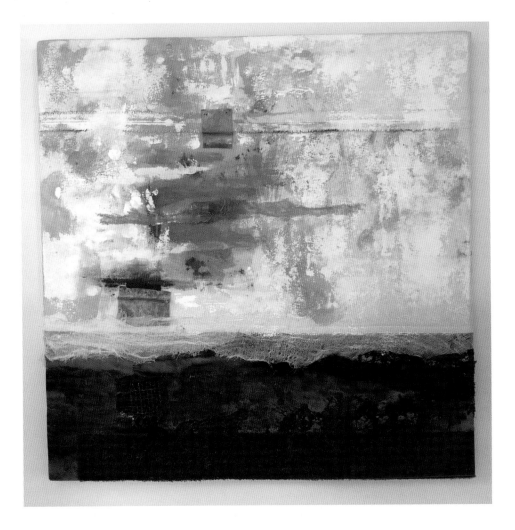

New life for aged fabric

Materials play a huge part in the planning of my work. The designs are freestyle with nothing plotted beforehand. My studio, when I'm starting a piece, is a huge mess. I work visually and need to be surrounded by cloth, fabrics, paper, and photos before anything can be started. The idea is not to replicate something seen, but to give a sense of place and time.

A piece of cloth will then set off the train of thought that will link it to an idea. Old fabrics hold a very special place in my work – the idea of reusing fabrics that have been handled by others in the past is all part of the process.

My work is abstract and has become more collage than quilted textile. Having specialized in embroidery when at college, I now like to distress that with over-painting, collaging, and use of paper, card, flashing, matting, scrim, and netting, but always including a small point of interest to make the viewer think further.

Antique shops and fairs are a good source for materials. If the fabrics are well used, mended, or coming apart, so much the better. I inherited my grand-mother's stash of old pieces of tweeds, cottons, buttons, 1930s suspenders (I'm still trying to work out how to use those!), studs, elastics, and wools. Natural fabrics have a very different feel than synthetics, as they fold, tear, fray, and shred in a random way, leaving natural edges, which add to the feel of the work. The work is all about textures and contrasts—leaving much to the imagination but hopefully enough to lead the viewer into the piece.

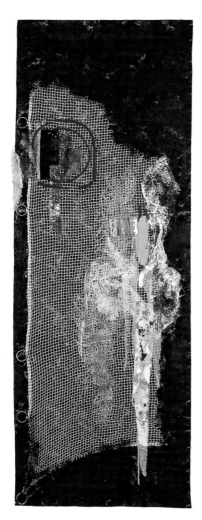
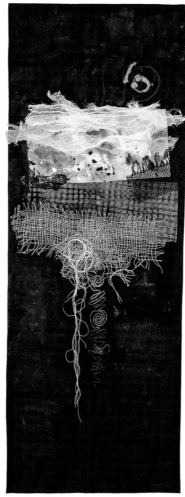
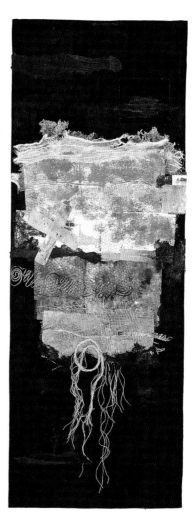

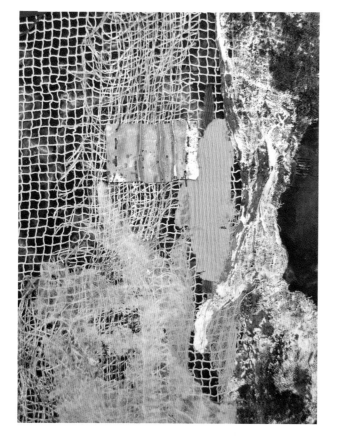

The Catch
55 × 80 inches (triptych
total), 2019, with detail

Crossing the Channel
40 × 24 inches, 2019

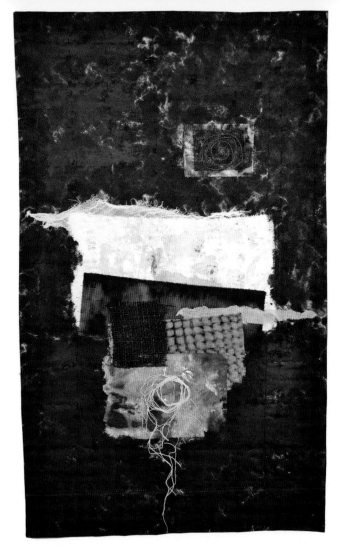

Tension
12 × 12 × 12 inches, 2019

Future plans

The goal of my work is to find the hidden traces of past lives and to never forget that we are here because of the past. The countryside and seascapes all have played their part.

There are two projects on the go at the moment—both unconnected and very different. One is work on seascapes—what happens both above and below the waterline and the contrast between. The changes of color of the seas depending on the times of day, the movement of the tides, the effect of the wind on the surface.

The other project started out as more of an experiment. For many years I've worked on the historical signs of past lives, and this new work follows on from there. I have a large collection of antique books—wonderfully fine tissue paper pages with charming pictures and embossed covers, very often tatty and falling apart. I wanted to use these in a piece, but the fragility was a problem. A local office was closing and gave me their old transparent folders. I enclosed the pages in the folders, and then I stabilized them with freehand machine stitching on water-soluble fabric. The result is that the pages are protected from any more damage, but their beautiful fragility and art can be seen. [See portrait on page 58.]

www.fenelladavies.com

Marcia DeCamp

PALMYRA, NEW YORK

Photo: Rikki Van Camp

Style markers

I grew up on a small dairy farm and remember sleeping under the hand- and machine-stitched quilts my mother had made as a girl for her hope chest. Finding those quilts in an attic many years later was my inspiration to start taking quilting classes.

I studied with Nancy Crow for several consecutive years, usually attending her two-week sessions, so my work is heavily influenced by her style. Geometric shapes dominate my work, and I'm fascinated with the relationships between them and lines.

My signature style is improvisational piecing. When I studied with Crow, I learned various techniques along with the principles and elements of good design and composition, but it wasn't until I started making the *Jet Trails* quilts that I found a way to express myself that felt unique to me.

Most of my evolution as a quiltmaker has been the process of becoming more and more comfortable with my own way of creating while implementing colors in an intuitive and spontaneous manner. I try to create a lot of movement and energy in my pieces. My work is best identified by its scale, which is usually quite large, and by my colors, which are vivid, high contrast, and improvisationally combined.

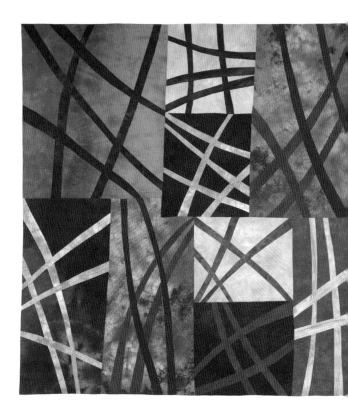

Jet Trails #11
72 × 72 inches, 2012

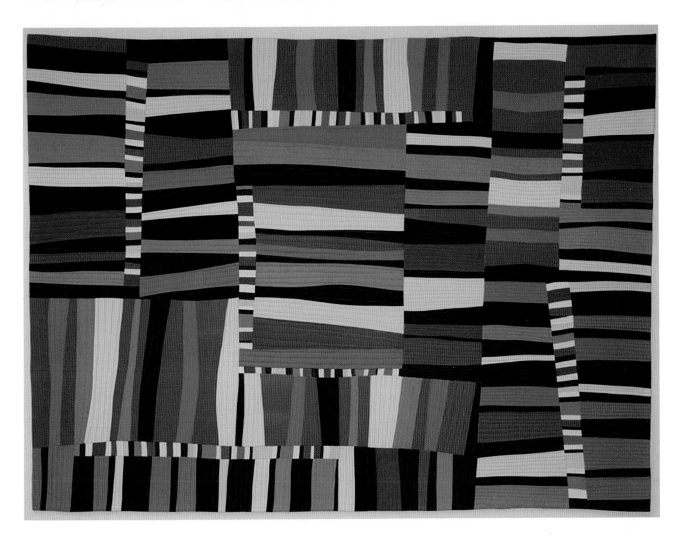

Doormats
49 × 67 inches, 2010

Series work

The *Jet Trail* series began when I took a walk down our country road at sunset and saw a particularly beautiful sky with a pattern of jet trails across it. Because we live far out in the country on almost 50 acres, I enjoy a great view of the skies, and seeing the many jet trails inspired a series I worked with from 2006 to 2013.

Over the years, I have also been very inspired by trips to the Southwest. I began to incorporate a strong palette of saturated southwestern landscape colors in my pieces. These colors and influences are most evident in the quilts in my *Slices* series.

Another interest is motifs, which usually evolve through sketches made with paper or fabric followed by lots of experimentation with fabric. I put segments up on the design walls in my studio and move them around, editing and revising them until I create a resolved composition.

I like to think that there's always more that can be explored, so there's no predetermined endpoint in my series. I like to move from one idea to another, and I let the various series overlap.

I have been part of a local critique group for several years, and from time to time we've taken on challenges that have led me to create works that are very different from my usual series. I'm currently in a group called Finger Lakes Fiber Artists that meets at the Schweinfurth Art Center in Auburn, New York, and includes artists from the Syracuse, Ithaca, and Rochester areas of New York State.

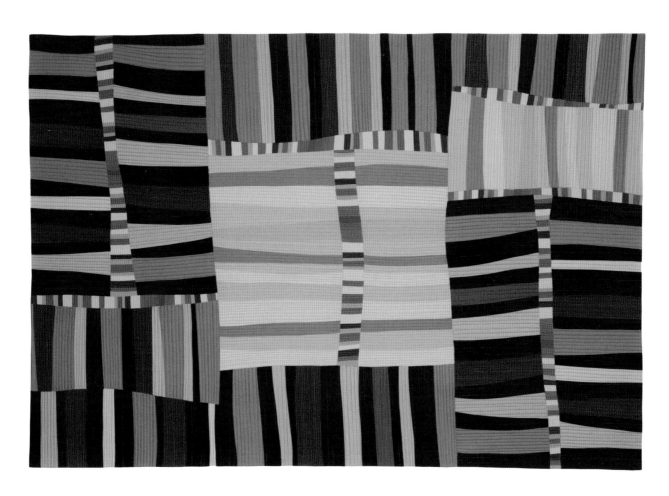

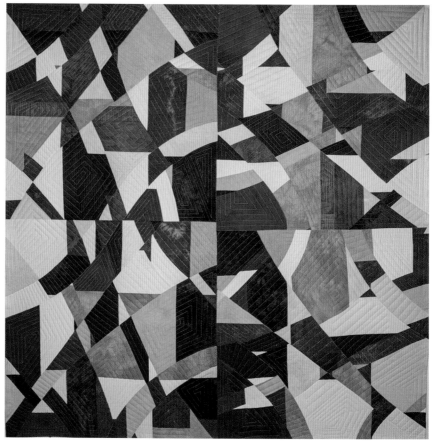

Design process

I am fortunate to have six large design walls and can have multiple pieces in process at the same time. Having in-process work on my flannel design walls allows me to easily arrange and rearrange the component pieces until the composition "works." If I'm struggling with a piece, I can move on to work on something else. But since "the problem piece" stays on the wall and in my view, I can look at it from time to time with fresh eyes and perhaps new inspiration.

I use a longarm quilting machine and like to keep my quilting lines geometric rather than feathered or flowery. I might do straight up-and-down lines or follow the line of a square in concentric smaller squares, but I don't mark the quilts beforehand, so my lines are more serendipitous and less than perfect. I like them to appear as if I drew them with my sewing machine.

The more recent pieces I've done, particularly in the *Slices* series, start with picking a palette of colors. I decide which color will be dominant. Then I create large, multicolored blocks that are stacked, sliced through, and resewn a number of times to see what kind of design comes forth.

If the composition uses a motif in the design, I do some sketching, then pick my colors and start creating segments. I work intuitively and improvisationally, so there's no detailed preplanning, and the work evolves as I'm creating it.

I don't deviate from traditional cottons, but I do predominantly use my own hand-dyed fabrics. I have the opportunity to go through my closets and find the right hues for a particular composition. After many years of dyeing, I've built a wide range of values and hues that provide me with a palette of fabrics that play well together.

What's ahead?

I am continuing to explore new work in the area I've called *Color Slices*, such as represented by my recent piece *Mango Salsa*. In this series I enjoy improvisational piecing using randomly cut shapes. I will select groups of colors that I want to use, but I do not have a preplanned end product in mind. I think it's a fun challenge to move the pieces around on the design wall as I go along and until I'm happy with the result.

I have been asked to participate in the US Department of State's Art in Embassies program. Ambassador Pasi selected my *Doormats* quilts to hang in the embassy in Addis Ababa, Ethiopia. I had previously participated in this program in 2015, when one of my quilts was selected for the embassy in Dili, East Timor.

marciadecamp.com

Commentaries

Linda Gass
Los Altos, California, USA
lindagass.com
Dogpatch, the sea is rising (0, 3 and 6 feet)
35 × 56 inches (89 × 142 cm), 2019
Photo: Don Tuttle

Willy Doreleijers
Dordrecht, Zuid Holland, Netherlands
willydoreleijers.nl
Industrial Revolution
51 × 35 inches (130 × 90 cm), 2018
Photo: Herman Lengton

Jeanne Marklin
Williamstown, Massachusetts, USA
jeannemarklin.com
Go Back Where You Came From
33 × 28 inches (84 × 71 cm), 2019

Nancy Billings
Miami, Florida, USA
nancybdesigns.com
Democracy . . . Hanging By A Thread
36 × 23 × 1.5 inches (91 × 58 × 3.8 cm), 2020
Photo: Fabrizio Cacciatore

Kathy Nida
El Cajon, California, USA
kathynida.com
Womanscape
82 × 54 inches (207 × 137 cm), 2018
Photo: Gary Conaughton

Teresa Barkley
Maplewood, New Jersey, USA
Tea Box to Ballot Box
74 × 58 inches (188 × 147 cm), 2019
Photo: Jean Vong

Melani Kane Brewer
Cooper City, Florida, USA
melanibrewer.com
When the Last Clinic Closes
37 × 34 × 7.5 inches (94 × 86 × 19.1 cm), 2019
Private collection. Photo: Matt Horton

Susan Schrott
Shelter Island, New York, USA
susanschrottartist.com
Tree of Life for Pittsburgh
53 × 77 inches (135 × 196 cm), 2018
Collection of Tree of Life - Or L'Simcha
Congregation. Photo: Christopher Burke

Mary-Ellen Latino
Nipomo, California, USA
highinfiberart.com
Shelter-In-Place AKA Urban Sanctuary
50 × 30 inches (127 × 76 cm), 2018
Photo: Joe Ofria

Therese May
San Jose, California, USA
theresemay.com
Protection
49 × 35 inches (124 × 89 cm), 2019
Private collection

K. Velis Turan
New Baltimore, New York, USA
kvelisturan.com
State of the Union
49 × 39 inches (124 × 99 cm), 2018

Judith Plotner
Gloversville, New York, USA
judithplotner.com
America Interrupted
36 × 35 inches (91 × 90 cm), 2018

Mary Ruth Smith
Waco, Texas, USA
Structure and Flow
17 × 24 inches (42 × 61 cm), 2019
Private collection

Bobbi Baugh
DeLand, Florida, USA
bobbibaughstudio.com
Sometimes You Can't See In
34 × 47 inches (85 × 119 cm), 2018

Deborah A. Kuster
Hot Springs Village, Arkansas, USA
deborahkuster.com
Parched Ground Will Become a Pool
37 × 29 inches (94 × 74 cm), 2020

Jayne Bentley Gaskins
Reston, Virginia, USA
jaynegaskins.com
On the Streets Where I Live
22 × 16 inches (55 × 39 cm), 2019

Carol Larson
Petaluma, California, USA
live2dye.com
Fire & Flood I
40 × 30 inches (102 × 76 cm), 2019

Susan Heller
Walnut Creek, California, USA
susanhellerfiberarts.com
Owner Operated
31 × 36 inches (79 × 90 cm), 2019
Photo: Jack Heller

Salley Mavor
Falmouth, Massachusetts, USA
weefolkstudio.com
Displaced
24 × 22 × 2 inches (61 × 56 × 5 cm), 2016
Private collection. Photo: Rob Goldsborough

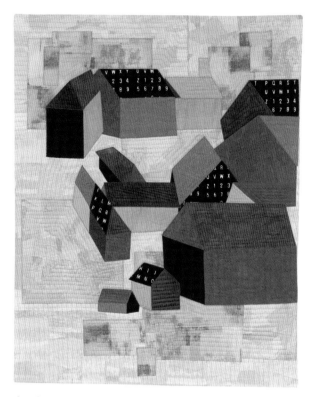

Geri Patterson-Kutras
Morgan Hill, California, USA
geripkartquilts.com
Shelter in Place
36 × 29 inches (91 × 72 cm), 2020

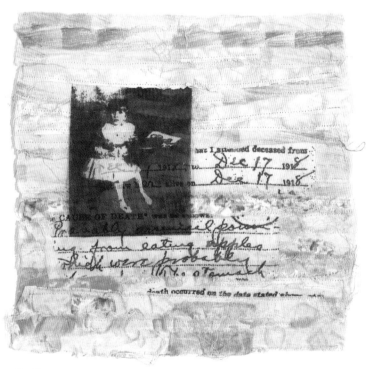

Pat Owoc
Saint Louis, Missouri, USA
patowoc.com
Arsenical Poisoning
10 × 10 inches (25 × 25 cm), 2019
Private collection. Photo: Casey Rae

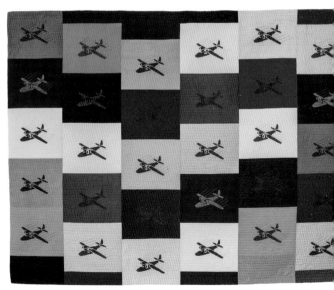

Margaret A. Phillips
Cos Cob, Connecticut, USA
Thirty Airplanes
51 × 63 inches (130 × 160 cm), 2018
Photo: Jay B. Wilson

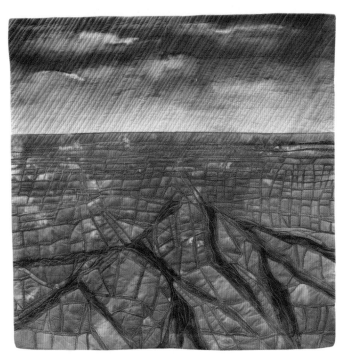

Lisa Walton
Lewisham, NSW, Australia
lisawaltonartist.com
Breaking the Drought #2
40 × 40 inches (102 × 102 cm), 2018
Photo: Margot Wikstrom

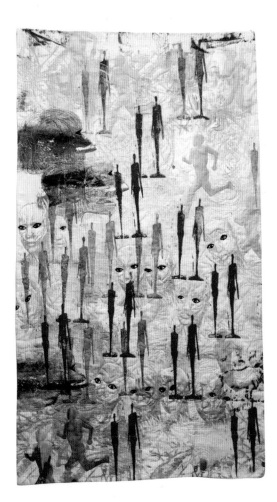

Regula Affolter
Oekingen, Solothurn, Switzerland
regaffolter.ch
Covid-19 Flucht #30 (Covid-19 Escape #30)
52 × 30 inches (133 × 75 cm), 2020
Photo: JEA

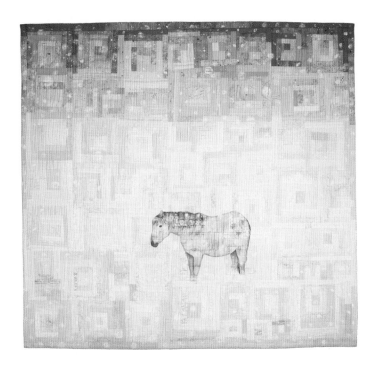

Joke Buursma
Portlaw, Waterford, Ireland
jokebuursma.weebly.com
Lonely
41 × 43 inches (103 × 109 cm), 2018

Changing Attitudes

SUZANNE SMITH ARNEY

The National Quilt Museum's guidepost is "Honoring Today's Quilter." This motto is the impetus behind every quilt, object, and exhibition claiming space within the galleries. These words over the building's entrance even apply to visitors, who may find their attitudes toward quilts changed.

The museum's foundation collection begins with two quilts from 1980: *Lancaster County Rose* (not pictured), by Irene Goodrich, and Virginia Avery's *Move Over Matisse I*. Both are handmade of appliquéd cotton blocks surrounded by a solid-color border. However, they could not be more different. *Lancaster County Rose* is a bed-size quilt based on the traditional Rose of Sharon pattern, while *Move Over Matisse I*, with its wiggly forms and elongated proportions, dances with vibrant shapes inspired by Matisse's legacy of paper cutouts. Long and narrow as a window, it avoids any reference to a bedcover.

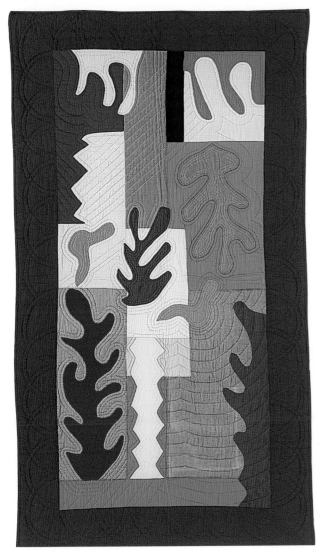

Move Over Matisse I
Virginia Avery
70 × 36 inches, 2001

The two quilts embody the split between traditional and art quilts—as well as the overlap. Judy Schwender, the NQM's former curator, says, "Liberating the quilt from the bed was a watershed moment. Now, instead of quilters saying, 'I'm going to make an art quilt,' we have artists who say, 'I choose to work in the quilt medium.' It's a whole different ball game."

Caryl Bryer Fallert-Gentry's *Corona II: Solar Eclipse* is definitely playing in that new ball game. It was the first machine-quilted object to win the American Quilter's Society Best of Show Award (1989) and is included in the book *The Twentieth Century's Best American Quilts*.

The three quilts mentioned so far are part of the National Quilt Museum's "Founders Collection," the founders being entrepreneurs Meredith and the late Bill Schroeder. Their enthusiasm for quilts developed from their interest in antiques and grew from there. They created the quilt business empire American Quilter's Society (AQS) in 1984. Its holdings include publications, quilt shows and contests, appraisal certification, product development, and more. In 1991, they founded the Museum of the American Quilter's Society in their hometown of Paducah, Kentucky, officially designated the National Quilt Museum of the United States in 2008. When she was inducted into the Quilters Hall of Fame in 2013, Todd Ford, writing in *Paducah Life*, described Meredith Schroeder as "a rock star in textile arts."

The museum's other collections include:

- Oh Wow! Miniature Quilts
- Footies Collection by Dorris Jane McManis
- Pat Campbell's Jacobean quilts
- The Paul D. Pilgrim Collection (a quilter and collector whose ideas contributed to the interior design of the museum)
- SAQA 25th Anniversary Trunk Show Collection

To see all the museum's quilts,
visit www.quiltindex.org.

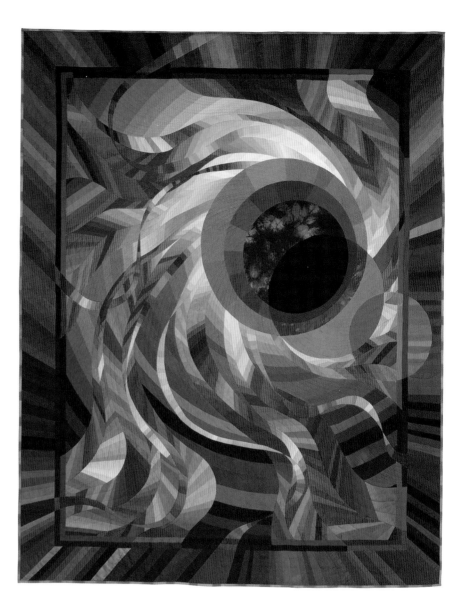

Corona II: Solar Eclipse
Caryl Bryer Fallert-Gentry
94 × 76 inches, 1989

Of the 170 quilts in the Founders Collection, about 20 percent would fit the Studio Art Quilt Associates (SAQA) definition of *art quilt*: "a creative visual work that is layered and stitched or that references this form of stitched layered structure." The museum has mounted several SAQA exhibitions, including *H₂Oh!*, a water-themed show that was on view this year. In addition, 50 quilts from the SAQA 25th Anniversary Trunk Show, selected by jurors B. J. Adams and Trudi Van Dyke, are part of the museum's permanent collection.

The museum's Collection Committee accepts one or two individual quilts each year from 15 or so proposed donations. A recent acquisition, *Rumors and Hard Times* by Susan Shie, came about when the owner was faced with a move. The committee was delighted to acquire the work of an artist of Shie's talent and influence, and the previous owner

has the satisfaction of knowing that the piece will receive proper care and attention and be available to a world of viewers.

To act on its vision of honoring today's quilters, the museum collects, exhibits, and advocates for the best of what quilters are making today. Style covers the spectrum from traditional to the most innovative. The museum mounts eight to ten exhibitions and averages 40,000 visitors per year. Education is a priority for the museum, with every visit an occasion for learning. More directly, the museum offers workshops for all ages and even has a Junior Quilters & Textile Artists Club for children aged 10–17. The Education Department believes that participants gain a broader understanding of creative expression and an awareness of fiber's potential.

That awareness has affected all of Paducah, now

recognized as a UNESCO Creative City in Crafts & Folk Art. The biannual AQS Paducah Quilt Show is bliss for quilt aficionados. Yeiser Art Center and shops such as Paper Pieces offer fiber finds, and Paducah School of Art and Design, a division of West Kentucky Community and Technical College, includes a recently installed fiber studio.

The process of organizing an exhibition is challenging. Curating an exhibit isn't simply picking 33 quilts that are pretty. Exhibitions tell a story. Each quilt must support that story and make it come alive. Exhibitions take visitors on a journey, introducing them to a place they had never been before. After researching the topic, selecting quilts, arranging for loans and shipping, developing individual gallery labels and overall supporting text, and obtaining images for promotion, the unpacking and installation of the quilts is almost anticlimactic. But if the visitor understands the story and is moved by it, the exhibit is a success.

Quilts of all kinds, from serene to scandalous, can be found at the National Quilt Museum. Look for the stories and be open to an attitude shift. You might find yourself exclaiming, "Oh, wow!"

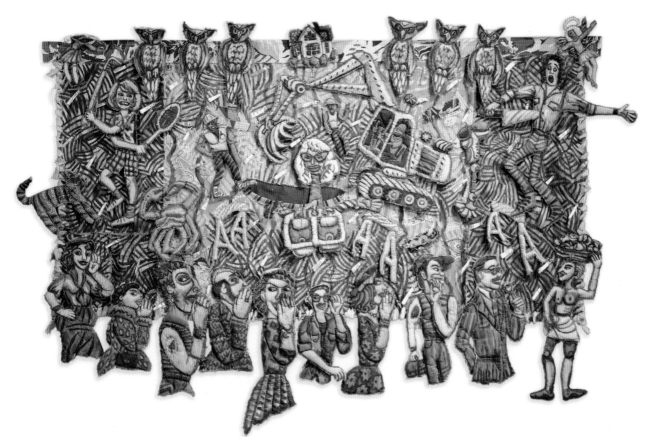

Rumors and Hard Times
Susan Shie
54 × 90 inches, 1989

Deborah Fell

URBANA, ILLINOIS

Quilts as art

My road to art quilts was never intentional. In my early 30s I realized that the only way I would ever have a quilt for my child was to learn to make one myself. I didn't know how to sew. I had only ever used the sewing machine as an art tool. In 1987 while living in New Hampshire, I took advantage of being a full-time mother and took 13 traditional quilting workshops.

For several years, making traditional quilts gave my heart great joy. In 1990, a loved one died in a horrific car accident in France. Having a nursing baby and no money for a plane ticket, I had to mourn in my own way. I stayed up one night and made a quilt top. I had never heard of an art quilt. Since this was before Google, there was not much information to research. Within a year, with the encouragement of my husband, I took my first national art quilting workshop.

Youth protects us from many things. I was young enough to have no idea that my first art quilt workshop, taught by Caryl Bryer Fallert-Gentry at the National Quilt Museum, was a very ambitious start to the study I have continued for over 20 years.

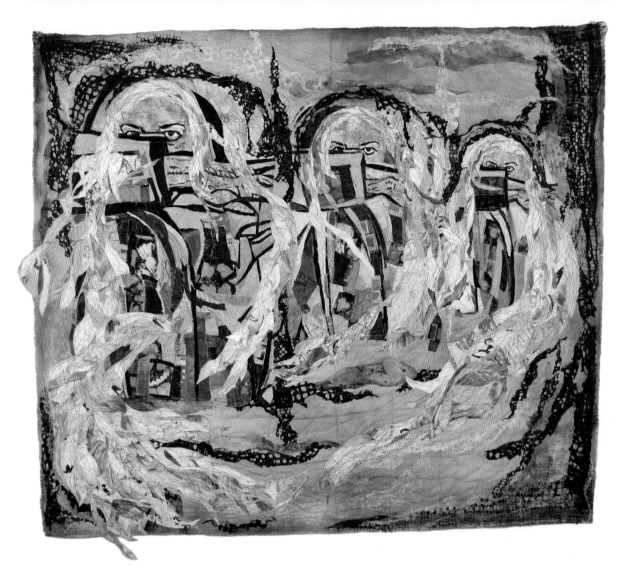

Pandora's Box

Left:
*Tuesday's Child: Does God Have
Enough Hands?*
57 × 38 inches, 2003

Above:
*Medusa and Her Imaginary
Friends*
55 × 63 inches, 2018

The primary environmental theme in my work is recycling. Tiny scraps of fabric and cutup clothing that would otherwise be discarded inspire me to create compositions with those materials. I am never too proud to dumpster-dive. Among my favorite found treasures are smashed, rusty bottle caps. Recycled materials are evident in my work that has been on exhibition in international juried exhibitions, museums, and publications.

My love of small pieces extends to the odd-shaped, tiny scraps that fall to the floor while I work. Those pieces are saved, sorted, and stored in large, color-coded bins. These remnants, whether they are the trimmed edges of a quilt, random shapes, or the inside of a denim seam, give me choices that I otherwise would never have. They are like a wealth of jewels.

Most people would call these tiny, random pieces of cloth garbage, but they are my starting place. I like to call my scrap bins Pandora's Box. Hunting and gathering pieces is often the first step in my design process. There is no end to the inspiration they provide, and the search turns into a sense of play that provides a wonderful base from which to start a design.

I have been working on my *Reclamation* series for 25 years. It conveys the beauty of imperfection and my love of repurposing materials. I have used this method for many types of quilts, including a 10-foot-high triptych that has the sensibility of a horizon.

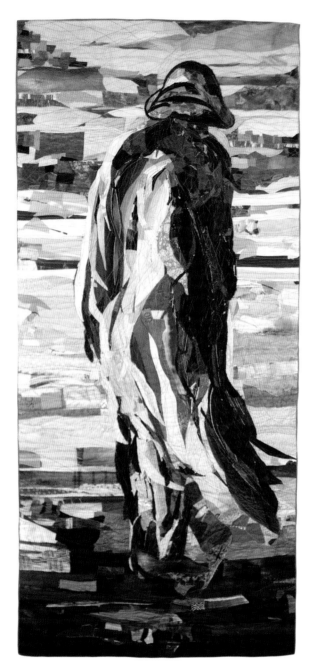

Beach Walk
69 × 32 inches. 2016

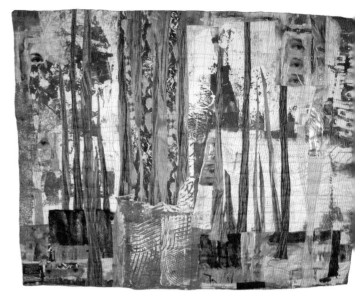

Witness Trees
39 × 48 inches. 2013

Reclamation Hudson
48 × 19 inches. 2017

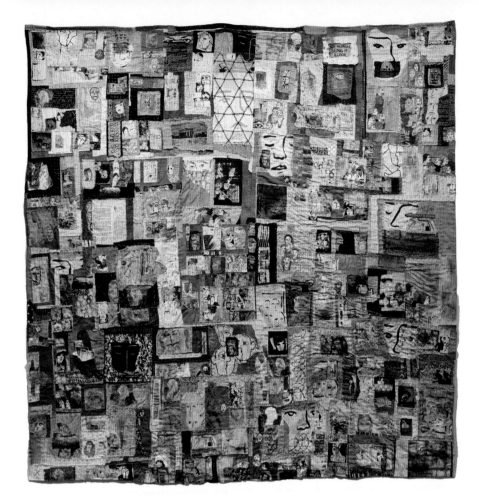

Faces in Cages
98 × 97 inches, 2020

Faces in Cages

Faces in Cages, a two-year project in my *Social Justice* series, was recently finished. This was the largest quilt I have ever created. About 100 by 100 inches, it is all stitched by hand. Some of my work responds to conditions such as basic human rights.

This quilt took two years. The initial intention was to bring awareness to our country's southern border treatment of refugees. Two years is a long time. As I was stitching the final pieces, it occurred to me that these faces go beyond the border crisis. So my question is—whose faces are these? Are these the faces of the COVID-19 pandemic that has taken over 100,000 lives in our country? Are they faces of people in the food pantry line? What about the children who have been killed in school shootings? Are these the faces of Holocaust murders? Is it George Floyd? I don't know the answers. You decide. Have we lost our way?

There are so many things in the world that are out of our control. Sometimes all we can do when witnessing injustice is to have hope that it will get better. Using these feelings in making art allows us to have a bit of control in our tiny part of the world. Art must be honest. Designing our way out of the sadness of the world with art makes us very lucky people. Addressing issues of humanity through art is a quiet, powerful way to feel in control when the world seems to be imploding around us.

www.deborahfell.com

Geometric Forms

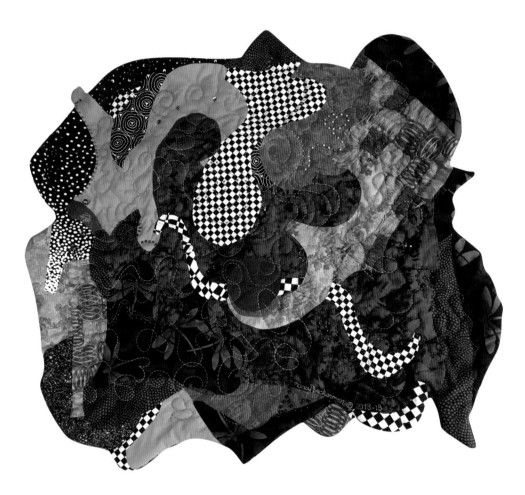

Nancy G. Beckerman
Pound Ridge, New York, USA
The Checkered Path Home
27 × 27 inches (69 × 69 cm), 2019
Private collection

Robbi Joy Eklow
Omaha, Nebraska, USA
robbieklow.com
Leftoverture
52 × 41 inches (132 × 104 cm), 2019

Lynne G. Harrill
Flat Rock, North Carolina, USA
lynneharrill.weebly.com
Sforzando
39 × 59 inches (99 × 150 cm), 2018

Mary Tabar
San Diego, California, USA
marytabar.com
Stones
34 × 44 inches (86 × 112 cm), 2020

Diane Melms
Anchorage, Alaska, USA
dianemelms.com
Synergy
74 × 74 inches (188 × 188 cm), 2015
Photo: Chris Arend

Pat Budge
Garden Valley, Idaho, USA
patbudge.com
Cow Lick
63 × 70 inches (160 × 178 cm), 2016

Meiny Vermaas-van der Heide
Tempe, Arizona, USA
artfulhome.com/artist/Meiny-Vermaas-van-der-Heide/625
Earth Quilt 116: Lines XXVI
41 × 41 inches (104 × 104 cm), 2004

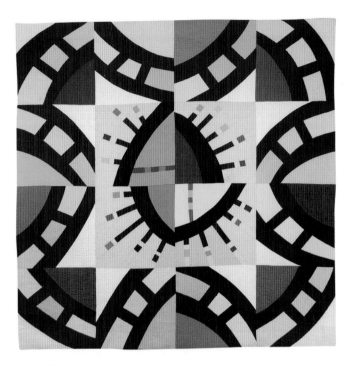

Cindy Grisdela
Reston, Virginia, USA
cindygrisdela.com
Kaleidoscope
57 × 57 inches (145 × 145 cm), 2018
Photo: Gregory R. Staley

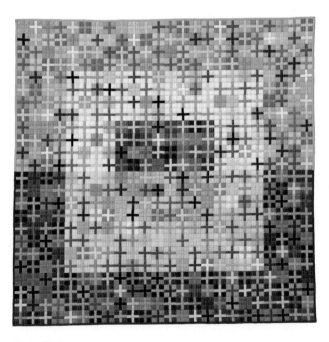

Kathy York
Austin, Texas, USA
aquamoonartquilts.blogspot.com
Two Halves
48 × 48 inches (122 × 122 cm), 2019

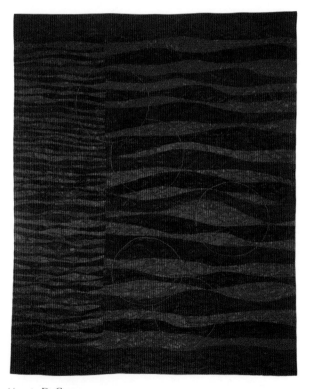

Marcia DeCamp
Palmyra, New York, USA
marciadecamp.com
River Styx
76 × 62 inches (193 × 157 cm), 2019

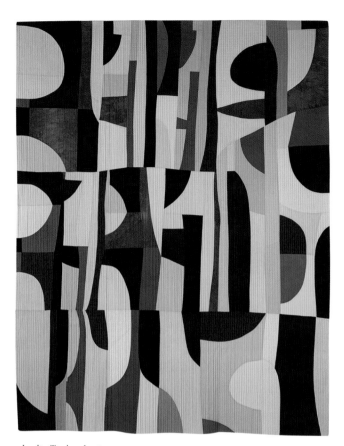

Paula Kovarik
Memphis, Tennessee, USA
paulakovarik.com
Dark Heart
46 × 55 inches (117 × 140 cm), 2019
Photo: Allen Mims

Leslie Tucker Jenison
Shavano Park, Texas, USA
leslietuckerjenisonv.com
El Greco's Alphabet
72 × 57 inches (183 × 145 cm), 2019

Stephanie Nordlin
Tucson, Arizona, USA
One Red Line
18 × 12 inches (46 × 30 cm), 2019

Frieda Lindley Anderson
Elgin, Illinois, USA
friestyle.com
Winter Trees
64 × 55 inches (161 × 138 cm), 2019

Gwyned Trefethen
Cohasset, Massachusetts, USA
gwynedtrefethen.com
Sunrise Over the Gulf River
32 × 47 inches (80 × 119 cm), 2019
Photo: Dana B. Eagles

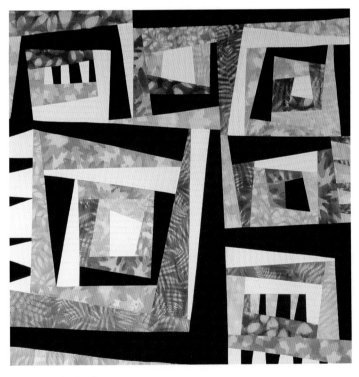

Polly Dressler Bech
Swarthmore, Pennsylvania, USA
pollybech.com
Off Kilter
46 × 46 inches (117 × 117 cm), 2019

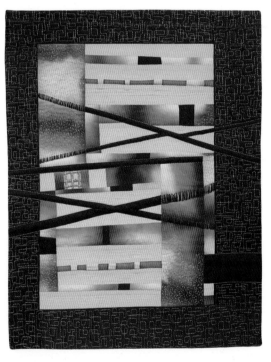

Lisa Jenni
Redmond, Washington, USA
Sticks
18 × 14 inches (46 × 36 cm), 2015

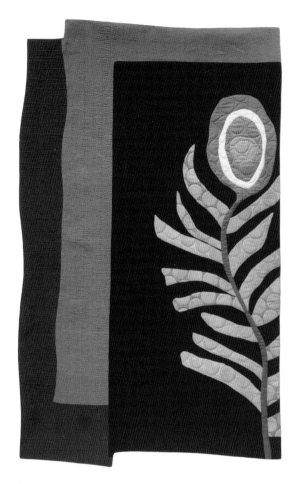

Tommy Fitzsimmons
Lakewood Ranch, Florida, USA
tommysquilts.com
Pretty Peacock
61 × 37 inches (155 × 94 cm), 2019

Irene Roderick
Austin, Texas, USA
ireneroderick.com
She's Lost Control Again
65 × 48 inches (165 × 122 cm), 2019
Private collection

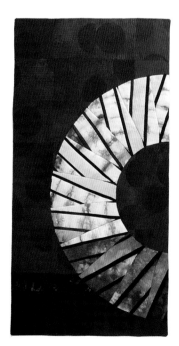
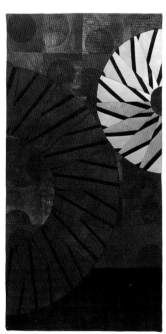
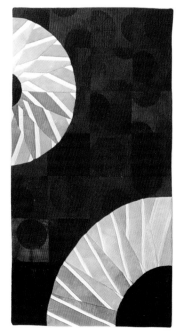

Lyric Montgomery Kinard
Cary, North Carolina, USA
lyrickinard.com
Mill Wheel XI: Revolution
40 × 64 inches (102 × 163 cm), 201

Maria Shell
Anchorage, Alaska, USA
mariashell.com
Everything All at Once
58 × 58 inches (147 × 147 cm), 2019
Photo: Chris Arend

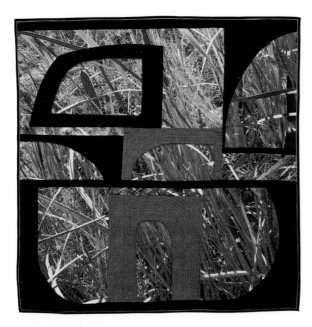

Bonnie J. Smith
Oxnard, California, USA
bonniejofiberarts.com
Alviso Drought
36 × 36 inches (91 × 91 cm), 2020
Photo: Bruce Burr

Heather Pregger
Fort Worth, Texas, USA
heatherquiltz.com
Australian Summer
44 × 37 inches (112 × 94 cm), 2020
Photo: Jason Voinov

Dianne Firth

CANBERRA, AUSTRALIA

Finding art quilts

I learned many craft skills growing up, including sewing. Although my career was in science and the built environment, I also studied arts and crafts for pleasure.

In my role as an academic at the University of Canberra, I help students acquire knowledge and skills that they will need to become landscape architects. I sometimes use my textile art to demonstrate ways of seeing, to sensitize students to different ideas, and to demonstrate other ways of communication. As a researcher, I ask questions, explore ideas, suggest new ways of understanding, and communicate through written and visual means. This feeds into my textile art in a subconscious way.

Inspiration abounds

My artwork often illustrates my lectures, and colleagues have used my images in publications, particularly as book covers. Many of my students say that my textile interpretations help them see places in a new way. One student presented her park design as a collaged and stitched picnic blanket.

Much of my work reflects an appreciation of the diversity of Australia's landscapes and the sense of place it creates. Ideas also derive from considering landscape as a system, a concept illustrated in *Secret River*, or how I might capture the ephemeral nature of light, air, and water with textiles, as seen in *Blown by the Wind*. Plants also offer possibilities, such as with *Floriade #3*.

Above left:
Botanicus
54 × 17 inches. 2019

Above right:
Cataract
20 × 20 inches. 2020

Material symbols

I use materials in a symbolic way, such as wool or felt to represent earth, and netting for air and water. I choose colors and textures that I associate with feelings and moods.

Sometimes, I create my own fabrics by dyeing, painting, or other mark making, but I use commercial fabrics too. I have made quilts with leaves, paper, and silver foil to test their possibilities. The materials need to relate to the intent of the artwork. I may layer with batting if I want density, hand-stitch if I want softness, or machine-stitch if I want a strong linear overlay.

I find that tearing cottons into thin strips makes them easy to manipulate. I can appliqué strips onto a base to create curving lines or blend torn fabric strips to create tonal fields as seen in *Cararact*.

Reverse appliqué is a technique I use with layers of bonded rather than woven materials. This gives a clean finish to the cut, and I use it to create complex lines and forms. When I want lightness in my work, I use net and assemble small pieces between the layers before machine-stitching everything together. I also like to set limits or constraints for myself, such as making a work with just two materials.

Style and process

I want my work to have overall simplicity and coherence, but to include interesting detail. Although my forms often derive from nature, they are abstracted. Therefore, I call my style abstract and minimal.

Black River
33 × 57 inches, 2020

Secret River
52 × 33 inches, 2019

Floriade #3
52.5 × 26.5 inches, 2021

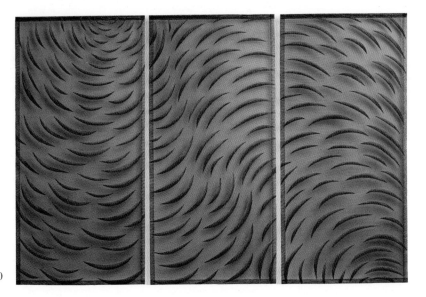

Blown by the Wind
53 × 81 inches. 2020

My process is similar to the one I use for architectural landscape work, but it's much freer and circuitous. The analysis phase involves sourcing materials, deciding on technique, final size, and how much time I have. Alongside this process is concept development, where a design forms through brainstorming, sketching, and exploring moods and feelings related to the idea and materials.

I used reverse appliqué techniques in a series exploring cell structures in plants. To achieve a three-dimensional effect, I used thick layers of commercial wool felt, which I cut into. This technique requires working by feel as well as sharp scissors and a strong hand.

To create a limited color choice, I selected a light, a medium, and a dark that related to the topic. I tacked the three layers together, marked a rough grid on the top layer with chalk, then machine-stitched over the lines, adjusting as needed to achieve flowing lines. I cut through the top layer to reveal the middle layer and then cut into the middle layer to reveal the bottom layer. I attached the pieces I removed from the front onto the back to cover the single layer of the base to make it a double-sided quilt. Finally, the edge was bound with a cover strip of felt.

What's happening

I was selected to make work for the prestigious Tamworth Textile Triennial exhibition, which travels to major galleries in Australia for three years. Its objective is to create a record of the changing nature and progress of textile practice from a national perspective.

Twenty textile artists from around Australia were invited to meet the curator, engage with the gallery, and discuss concepts around the theme of Tensions 2020. After that engagement I made the triptych *Blown by the Wind* as a meditation on the drought Australia was experiencing at that time.

My aspiration is to have a dedicated quilt studio with a large design wall and large layout table, to be able to make large work.

www.ozquiltnetwork.org.au/gallery/dianne-firth

Linda Gass

LOS ALTOS, CALIFORNIA

Textile journey

I didn't become aware of art quilts until I was in my 30s, and I discovered a Quilt National catalog. The book included images of quilts like none I had seen before, inspiring me to seek out exhibitions to see more art quilts. At that time, I painted watercolor landscapes of wilderness areas where I backpacked and camped. Then I attended a hands-on silk-painting demonstration and was mesmerized by the dyes flowing into the silk. I realized that silk dyes were similar to water-colors, and I could use them to create fabrics.

I tend to focus on environmental issues, particularly climate change, water, and land use. Oftentimes my work has an element of time to it where I explore how landscapes change over time, focusing on those places where destruction and renewal, wounding and healing, absence and presence overlap.

As a young child in the 1960s, I was exposed to the "Give a hoot, don't pollute" campaign, which was followed by the environmental reforms of the 1970s, including the Environmental Protection Agency, the Clean Air Act, the Clean Water Act, and the Endangered Species Act. I don't really know what inspired me to become involved. I was sensitive to what was going on around me, and reacted to the injustices against our environment. I remember as a child, it would hurt my lungs to breathe the polluted air in Los Angeles; I think that was when I made a conscious connection between the environment and health.

Although I've lived in California most of my life, I didn't learn about California water issues until I was an adult. When I became a full-time artist, I found myself making art about water. I don't recall it being a conscious decision. It happened naturally, most likely because of my passion for the environment and a desire that my art be an outgrowth of my activism. Today, I would describe my style as "artivism."

Photos by Don Tuttle unless otherwise indicated

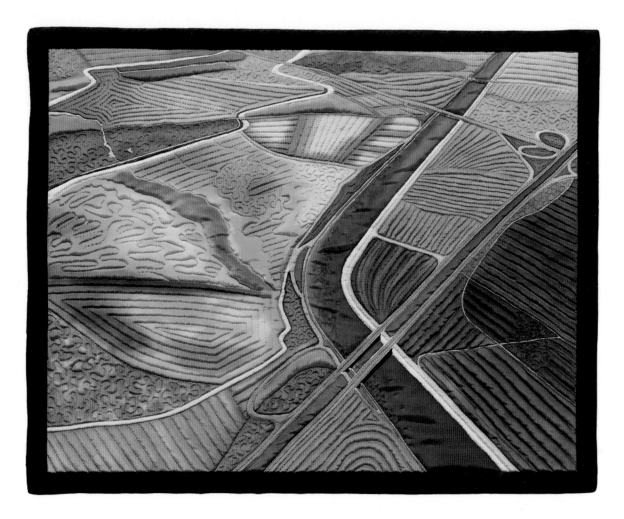

After the Gold Rush
21 × 26 inches, 1998

Materials matter

My subject matter can be challenging and uncomfortable, yet I want to encourage people to experience my work. By using a soft, familiar material such as textiles, I can accomplish that goal. The process of working with textiles also echoes the themes of destruction and renewal in my work. In preparation for painting on silk, I commit many of the same destructive acts that humans have done to the landscape. I cut into the fabric, tear it, and poke holes into it with needles. As part of the silk-painting process, I build the equivalent of dams and dikes, using resists to contain liquid silk dyes. After I finish painting, I begin the stage that resembles healing (mending) and renewal (repair) as I stitch my work by machine and by hand.

Creating impact

My artwork takes strong positions about controversial environmental issues, and it's my intention that the message in my work comes through when people experience it. I hear from people who have been touched by my artwork, and I'm proud that pieces have been selected for several public art projects centered around healing and the environment. My work is installed at Zuckerberg San Francisco General Hospital and Trauma Center, the new UCSF Bakar Precision Cancer Medicine Building, University of Chicago Medicine, and the Alameda County Department of Environmental Health. It also is in several museum, corporate, and private collections.

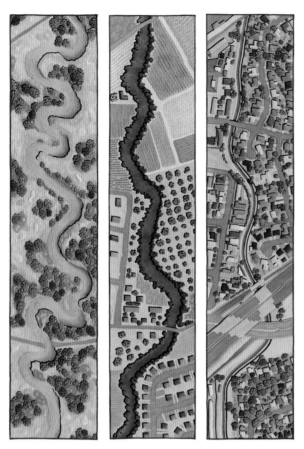

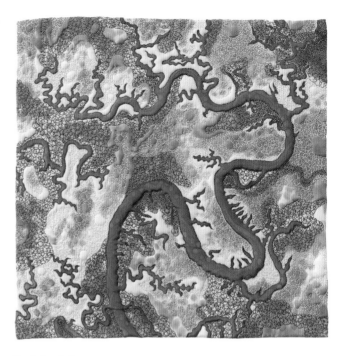

Rendering Salt
10 × 10 inches, 2018

Urban Power vs. San Lorenzo Creek, What's next?
59 × 12 inches, 2019

Severly Burned: Impact of the Rim Fire on the Tuolumne River Watershed
54 × 70 inches, 2014

Some day there may be no more snow: California snowpack 1960-2019
56 × 90 × 1.25 inches, 2019
Photo by the artist

What's next?

I recently completed three commissions. One was a public art commission for the new Community Center in Los Altos, California, where I collaborated with a mural artist to create two interior murals based on the watersheds of Los Altos. The mural artist painted my designs showing the stitches and shading.

A second commission was for an exhibition titled *Dissolve* at the Institute and Museum for California Art at UC Irvine in Southern California. I collaborated with a faculty member in anthropology, Valerie Olson, PhD, to create a multimedia artwork inspired by an ethnographic report of community strengths and needs she worked on for the Santa Ana River Watershed Project Authority to improve agency-community interactions and develop locally defined responses to large-scale problems such as flooding, water quality, and drought.

The third commission was for a new affordable housing development in San Jose with supportive housing for the homeless. I created a design for the window facade in the two-story-high lobby, based on the changes over time to the nearby Los Gatos Creek.

Recently the International Quilt Museum in Lincoln, Nebraska, contacted me to acquire my work *After the Gold Rush* for the new Quilt National Collection. *After the Gold Rush* was my first stitched aerial landscape painting on silk and won the Rookie Award (now the Emerging Artist Award) in Quilt National 1999. I never sold this artwork, in the hopes that it would eventually find a home in a museum collection, and I feel honored to have it join this important collection of award-winning Quilt National artworks.

Mita Giacomini

DUNDAS, ONTARIO, CANADA

Fiber art

I was delighted to participate in SAQA's exhibit at *Intersect Chicago: The Future of SOFA*, and to give an artist talk at the event. It was great to have that audience not only for introducing my artwork but also for demonstrating some special qualities of the fiber art medium for image making. I hope fiber will continue to rise in respect and appreciation in the fine art world, where hierarchies sometimes still operate among media and disciplines.

Observing as habit

One of the great joys of living as an artist is that everything becomes intensely interesting and full of instruction and possibility. Before I devoted full-time to my art practice, this habit of looking was distracting. Now it's essential, a great blessing, and how I work around the clock.

I am drawn to transient moments that might ordinarily be barely noticed, but when held in focus, they expand into wider and more vibrant experiences. Right now, most of my pieces are inspired by fleeting, intimate encounters in nature, particularly with individual creatures or light in flux. For birds, I focus on moments of meeting eye to eye or the privilege of observing a bird who is wrapped up in its own private world.

I work on themes and with materials that captivate me, and the process of surface weaving that I've developed is deeply contemplative. Just as I spend a lot of time creating a piece, I want to offer viewers the opportunity to look at it for a long time and always find something new to see.

Abide
20 × 20 inches, 2018

Repose
20 × 26 inches, 2020

My relationship with my materials is a force of its own and leaves its imprint on everything I make. This attitude is influenced by the many and serendipitous ways I collect the strands, and how I organize and access them in the studio. I reorganize my studio regularly, not so much to tidy up as to get reacquainted and develop new connections with my materials.

The restrictions of the pandemic gave me an opportunity to focus intensely on local wildlife, not only as individuals but also their situation in our town. We have a unique and precious winter flock of waterfowl on the shore of Lake Ontario; the trumpeter swans among them were endangered until recent years. In the dead of winter, it is a joy and a wonder to stand in the presence of this growing swan population—along with acres of Canada geese and assorted ducks. Recent pieces *Repose* and *Two Minds* are part of a new series focused on these birds and the experience of being with them.

Surface weaving

Pointillist color work breaks areas of one color into many smaller marks of its constituent colors. For example, many yellow and red marks blend at a distance to suggest an orange hue. Because of the laws of optical color mixing and perception, the viewer experiences a dynamic flickering sensation that's visually exciting.

In surface weaving, each strand of fiber is woven in a random path that becomes many strokes of color. Also, fiber itself is naturally a "pointillist" medium, as many fabrics and yarns possess some variegation. Besides yarns and strings, I also weave with torn fabric strips. Surface design makes these materials more expressive and exciting. I dye, print, or paint many of my fabrics. I also use a lot of commercial, vintage, and artisanal fabrics and yarns.

Left to right:

Glimmer
15 × 15 inches, 2020

Two Minds
22 × 22 inches, 2021

Constant, with detail below
31 × 31 inches, 2019

Creative process

All work begins with the concept underlying the series, and each individual piece involves numerous preliminary studies. Surface weaving is time consuming, and I need to really be invested in an image to commit to weaving it.

I start with observations and often my own photos. I select images that best capture the feeling of the moment, the subject, and my own response to it. I make many preliminary drawings to work out the general composition, colors, and so forth. The surface-weaving stage involves stitching—by machine, hand, or both—onto the base fabric, then needle-weaving over the surface among these stitches until a dense textile forms. When the hand-weaving stage is complete, I free-motion-quilt the surface-woven fabric to batting and one or more layers of backing material.

I've found that every piece doesn't work well at some point. The way my technique unfolds, each piece goes through an ugly messy stage, and most reach a moment when I've lost perspective or am frankly a bit sick of it. This stage is transient and probably necessary, so I've learned to forge ahead without generating drama. The best remedy in most cases is to apply time—a rhythm of working and breaking from work—and to allow each piece to marinate out of sight for a while. I revisit it later with a refreshed eye and my own idiosyncratic criteria for critique, and solutions appear.

What's ahead?

I'll be investigating the potential of surface weaving for a long time. It's as versatile a medium as painting or drawing. I have many more bird portraits in progress, particularly a subseries focused on local urban wildlife. Other series I have underway are inspired by textiles themselves or semi-abstract impressions of broader natural environments—landscape, forest, water, and air. I've also ventured into three-dimensional work, and am excited to explore surface weaving's sculptural possibilities.

www.mitagiacomini.com

Sense of Place

Deborah Fell
Urbana, Illinois, USA
deborahfell.com
Passage of Time: Braunschweig 3
70 × 58 inches (178 × 147 cm), 2016
Private collection

Ann J. Harwell
Wendell, North Carolina, USA
annharwell.com
Off the Grid
47 × 38 inches (119 × 97 cm), 2019
Photo: Dick Cicone

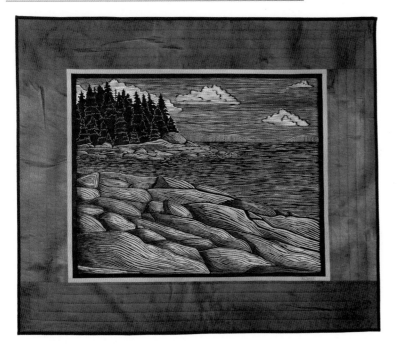

Jill Jensen
Lynchburg, Virginia, USA
jilljensenart.com
Coastal Rocks
34 × 40 inches (86 × 102 cm), 2019

Julia Graber
Brooksville, Mississippi, USA
juliagraber.blogspot.com
Tower of Pisa
10 × 8 inches (25 × 19 cm), 2019

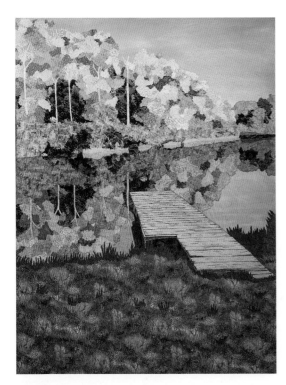

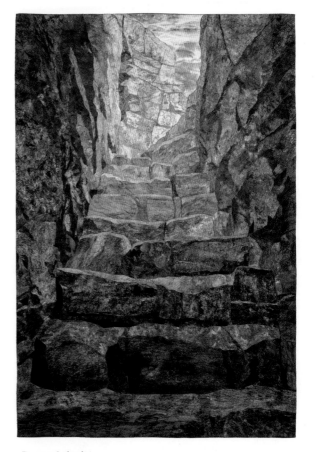

JoAnn Camp
Greenville, Georgia, USA
Reflections
39 × 30 inches (100 × 75 cm), 2019
Photo: Kenny Gray

Denise Labadie
Lafayette, Colorado, USA
labadiefiberart.com
Bonamargy Friary
61 × 42 inches (155 × 107 cm), 2018
Photo: Allan Snell

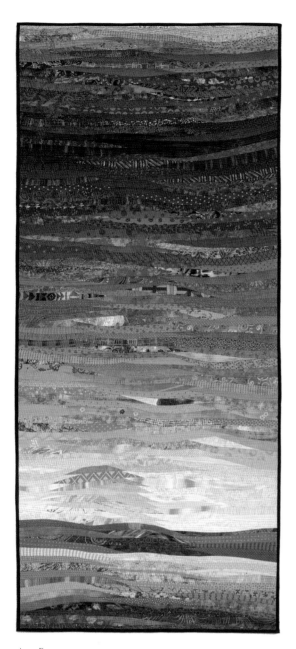

Ann Brauer
Shelburne Falls, Massachusetts, USA
annbrauer.com
Autumn Sunset
72 × 30 inches (183 × 76 cm), 2018
Private collection. Photo: John Polak

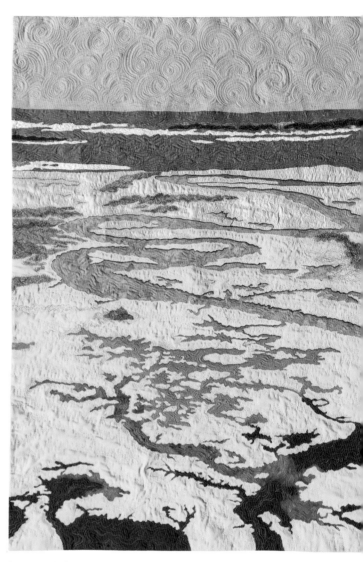

Susan Brubaker Knapp
Chapel Hill, North Carolina, USA
bluemoonriver.com
Bald Head Island Marsh: After the Storm
46 × 32 inches (116 × 80 cm), 2018

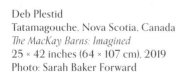

Deb Plestid
Tatamagouche, Nova Scotia, Canada
The MacKay Barns: Imagined
25 × 42 inches (64 × 107 cm), 2019
Photo: Sarah Baker Forward

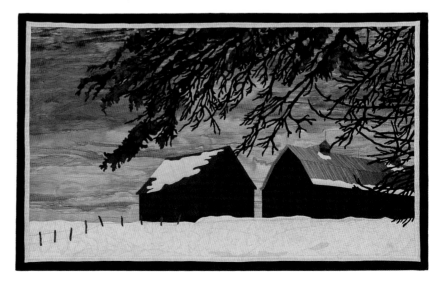

Virginia A. Spiegel
Byrib, Illinois, USA
virginiaspiegel.com
Boundary Waters 88
40 × 40 inches (102 × 102 cm), 2017
Photo: Deidre Adams

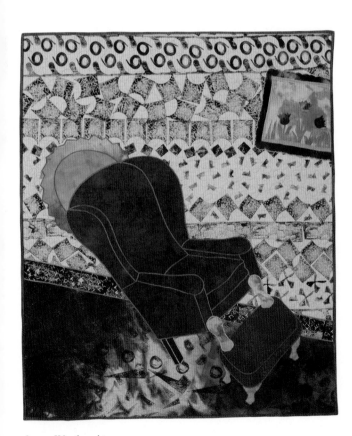

Laura Wasilowski
Elgin, Illinois, USA
artfabrik.com
Nude Blue Chair Reclining
50 × 42 inches (127 × 107 cm), 1996

Anna Chupa
Easton, Pennsylvania, USA
annachupadesigns.com
Barcelona Impressions
36 × 36 inches (91 × 91 cm), 2019

Isabelle Wiessler
Gundelfingen, Germany
isabelle-wiessler.de
Horizonte 6
35 × 54 inches (90 × 138 cm), 2019
Private collection

Sharon Bass
Lawrence, Kansas, USA
smwbass.com
Waterline #2, Willamette River
48 × 26 inches (122 × 66 cm), 2018
Private collection. Photo: Ken Sanville

Vicki Conley
Ruidoso Downs, New Mexico, USA
vicki-conley.com
Paths Seldom Traveled
48 × 28 inches (122 × 71 cm), 2020
Photo: Doug Conley

Arlene L. Blackburn
Union Hall, Virginia, USA
arleneblackburn.com
Sense of Place: Mesa Verde
37 × 33 inches (93 × 83 cm), 2020

Sue Holdaway Heys
Ann Arbor, Michigan, USA
sueholdawayheys.com
Hershey Road
40 × 40 inches (102 × 102 cm), 2020
Photo: Teri Elwood

Doria A. Goocher
San Diego, California, USA
designsbydoria.com
Seaside
25 × 18 inches (64 × 46 cm), 2020

Jo-Ann Golenia
Venice, Florida, USA
joanngolenia.com
Gifts from the Sea
33 × 55 inches (84 × 140 cm), 2010

Heather Dubreuil
Hudson, Quebec, Canada
heatherdubreuil.com
Old Town Square, Riga
18 × 24 inches (46 × 61 cm), 2018

Margaret Lowers Abramshe
St. George, Utah, USA
metaphysicalquilter.com
Sky Lanterns
49 × 32 inches (124 × 81 cm), 2019

Bev Haring
Longmont, Colorado, USA
Out to Pasture
37 × 47 inches (94 × 119 cm), 2020

Joan Sowada
Gillette, Wyoming, USA
joansowada.com
Long View
38 × 53 inches (97 × 135 cm), 2019
Wyoming State Hospital. Photo: Ken Sanville

Jeannie Palmer Moore
Kerrville, Texas, USA
jpmartist.com
Buck
39 × 25 inches (99 × 64 cm), 2020

Denise Oyama Miller
Fremont, California, USA
deniseoyamamiller.com
Sanctuary
31 x 41 inches (79 x 104 cm), 2019
Photo: Sibila Savage

Art Quilts in the Museum

JENNIFER SWOPE

The Museum of Fine Arts, Boston, presented a selection of its most extraordinary American quilts and bedcovers collection, spanning three centuries, in a publication and exhibition, *Fabric of a Nation: American Quilt Stories*. Both explored how these textiles resonate with many untold stories of people who have played a vital role in the complicated history of North America. Actively building a quilt collection at the MFA began only two decades ago, and acquiring late 20th- and 21st-century quilts remains a priority. The MFA's reinterpretation of its historic quilt collection and expansion of its contemporary one is highlighting the place for quilts in the canon of American art.

Bisa Butler's *To God and Truth* reanimates figures in an 1899 photograph of baseball players at Morris Brown College in Atlanta, one of 300 pieces chosen by W. E. B. DuBois to exhibit at the 1900 Paris Exposition Universelle to illustrate African American progress after Emancipation. Using layers of appliquéd and painted textiles, Butler conveyed the individuality of each figure, rendering these scholar-athletes in innumerable printed cottons that include Nigerian hand-dyed batiks, African wax-resist cottons, South African shwe-shwe cloth, and Ghanian kente cloth. With pieced and appliquéd nylon netting, other synthetics, and knotted cotton, Butler created surface depth that she further explored in the machine-quilting process.

Kanienkeháka (or Mohawk) artist Carla Hemlock also brings historical issues to a contemporary audience in the disarming form of a quilt. In *Survivors*, Hemlock altered what she describes as a traditional settler pattern with a ring of appliquéd red figures inspired by those found in wampum belts, which continue to serve as a guide to Haudenosaunee (or Iroquois) history and traditions. Hemlock says the 48 beadwork wampum figures in the outer border include names of "the Native Nations that have survived centuries of genocidal policies by settler government to wipe out our identity and our People's existence." Hemlock's hand quilting plays on the tension between comforting and domestic associations of quilts contrasted with these themes.

When Susan Hoffman began making quilts in the mid-1970s, she assumed that it would be just a matter of time before these works of art would be recognized as such. In this sense, she considers all quilts to be political because they challenge hierarchies within the art world. Like much of Hoffman's work, *Love Meditation* continues her exploration of color and pattern within abstract geometric composition. She has described her initial breakthrough in the quilt medium as occurring when she began placing pieces of cloth on the floor of her studio apartment, like "long brushstrokes." She describes the hand quilting that she does for each work as a mediation that "breathes life into the front of the quilt."

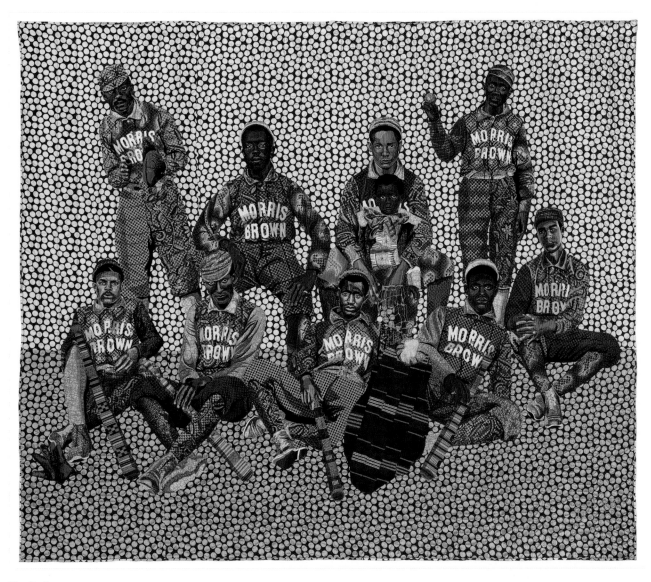

Bisa Butler
To God and Truth[1]
117.5 × 140.5 inches, 2019

Carla Hemlock
Survivors[2]
79 × 76 inches, 2011–2013

Trained in tapestry weaving and ceramics, Nancy Crow became engaged with the symmetrical geometry of piecing in the mid-1970s, creating some of the most visually dynamic quilts of the 1980s and 1990s. *Constructions No. 8* is part of a series that marks Crow's dramatic shift away from precise piecing with rulers to using a rotary cutter in a freehand, improvisational way. The shifting color intensities of the quilt's hand-dyed cottons, with irregular rhythms of undulating lines between the long stripes and blocky squares in the composition, demonstrate Crow's mastery of her medium.

Michael James's *Grid with Colorful Past* exemplifies a new direction his work has taken in the 21st century. A leading artist, writer, and teacher whose work in all of these areas has elevated the field of contemporary quilting, James was formally trained in painting and printmaking but switched to making quilts in the mid-1970s. In this quilt, James departed from making large-scale works featuring stripes of undulating color, which characterized his work of the 1980s and 1990s. As part of his *The Life in a Day* series, James composed this quilt top in a single day from pieces of digitally printed textiles that he had created. These self-imposed parameters induced what James has described as the "visual free verse" inherent in this series of innovative quilts.

Japanese American artist Tomie Nagano created *Indigo Colour Mixture* as part of her *Two Hearts in Harmony* series. Descended from 19th-century Japanese settlers of Hokaido who had deep traditions of spinning, dyeing, and weaving, Nagano hand-pieces and quilts textiles from recycled kimonos dating from the late 19th to mid-20th century. Inspired to make quilts in the mid-1980s after her mother gave her kimonos owned by her grandparents, Nagano continues to honor these earlier generations through her textile art.

Mike McNamara's *Rooster Quilt* combines vintage quilt blocks ranging from the 1940s to 1980s. McNamara finished the quilt top by inviting artist Bonnie Minardi of Santa Cruz, California, to paint

Susan Hoffman
Love Meditation[3]
96 × 93 inches, 2011

whatever inspired her. A member of the Quilters' Connection in Watertown, Massachusetts, and the Parajo Valley Quilters' Association of Santa Cruz, California, McNamara made his first quilt in 1976. In the mid-1980s, while living in Boston, he made many textile panels for friends and loved ones for the NAMES Project, commemorating those who had died from AIDS.

Only a selection of the important quilts made since 1975 in the MFA's collection of 40 such works, these masterworks show the range of the medium in the hands of these extraordinary artists.

Jennifer Swope is Assistant Curator in the David and Roberta Logie Department of Textiles and Fashion Arts at the Museum of Fine Arts, Boston. A recipient of a Lois F. McNeil Fellowship to attend the Winterthur Program in American Culture, she received a master's degree in American Material Culture from the University of Delaware. She is coauthor and curator of *Quilts and Color, the Pilgrim/Roy Collection*, a catalog and exhibition that opened at the MFA in 2014.

Nancy Crow
Constructions No. 8[4]
40.5 × 37.5 inches, 1997

Michael F. James
Grid with Colorful Past[5]
35.5 × 46 inches, 2007-2008

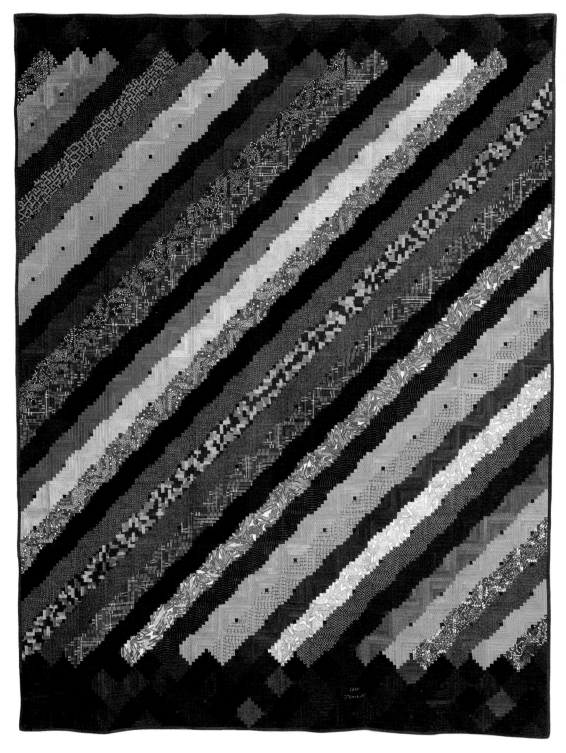

Tomie Nagano
Indigo Colour Mixture[6]
121 × 96 inches. 2004

Mike McNamara
Rooster Quilt[7]
92 × 78.5 inches, 2015

Credits

1. *To God and Truth*
Bisa Butler
Printed cotton; pieced, appliquéd, and quilted
John H. and Ernestine A. Payne Fund, the Heritage
Fund for a Diverse Collection, and Arthur Mason
Knapp Fund
Photograph ©Museum of Fine Arts, Boston
Collection of the Museum of Fine Arts, Boston
(2019.2200)

2. *Survivors*
*Carla Hemlock (Haudenosaunee, Kanienkeháka [Mohawk],
born 1961)*
Cotton plain weave, pieced; glass beads, applied;
cotton and polyester
batting, quilted
The Heritage Fund for a Diverse Collection
Reproduced with permission
Photograph ©Museum of Fine Arts, Boston
Collection of the Museum of Fine Arts, Boston
(2019.1943)

3. *Love Meditation*
Susan Hoffman (American, born 1953)
Cotton and cotton-polyester blends in plain weave and
other structures; machine pieced, hand-quilted
Gift of Susan Hoffman
© Susan D. Hoffman
Photograph © Museum of Fine Arts, Boston
Collection of the Museum of Fine Arts, Boston (2019.2284)

4. *Constructions No. 8*
Nancy Crow (American, born 1943)
Dyed and hand-quilted cotton
The Daphne Farago Collection
©Nancy Crow
Photograph ©Museum of Fine Arts, Boston
Collection of the Museum of Fine Arts, Boston
(2017.4834)

5. *Grid with Colorful Past*
Michael F. James (American)
Cotton plain weave digitally printed; machine- pieced,
machine-quilted
Gift of Christin J. Mamiya
©Michael F. James
Photograph ©Museum of Fine Arts, Boston
Collection of the Museum of Fine Arts, Boston
(2019.2287)

6. *Indigo Colour Mixture*
Tomie Nagano (Japanese American, born 1950)
Cotton plain weave; cotton filling; pieced and quilted
with polyester thread
Gift of Wayne E. Nichols
Reproduced with permission
Photograph ©Museum of Fine Arts, Boston
Collection of the Museum of Fine Arts, Boston
(2015.3122)

7. *Rooster Quilt*
Mike McNamara (American, born 1952)
Pieced printed cotton plain weave top; printed cotton
plain weave back and binding; machine- quilted; fabric
paint (Versatex)
Gift of Mike McNamara
Photograph ©Museum of Fine Arts, Boston

INTERVIEW WITH

Cindy Grisdela

RESTON, VIRGINIA

Photos: Gregory R. Staley

Signature style

My combination of color, line, and shape creates graphic designs that encourage viewers to take a closer look, similar to how a painter uses paint. Color is usually my starting point, and I often gravitate to bright colors. I also enjoy the challenge of choosing colors outside my comfort zone, such as neutrals, browns, or dusty pink. A surprise color or value—the "spark"—elevates my designs with an unexpected accent, like the use of turquoise in *Neapolitan*.

My style has evolved dramatically over my 30-year art career, ranging from traditional patterns and hand quilting to improvisational design and free-motion stitching. It didn't happen overnight. At first, I tweaked my favorite traditional patterns, including Log Cabin and Drunkard's Path, as I developed a more contemporary aesthetic, one that pays homage to my traditional roots but is more original in execution.

Some of my quilts are block-based and others are based on freehand cutting and design. They all have common elements that identify them as my work. My strengths are a good sense of color and design, as well as free-motion quilting skills.

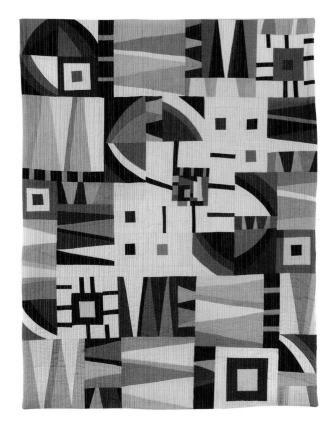

Neapolitan
36 × 32 inches, 2020

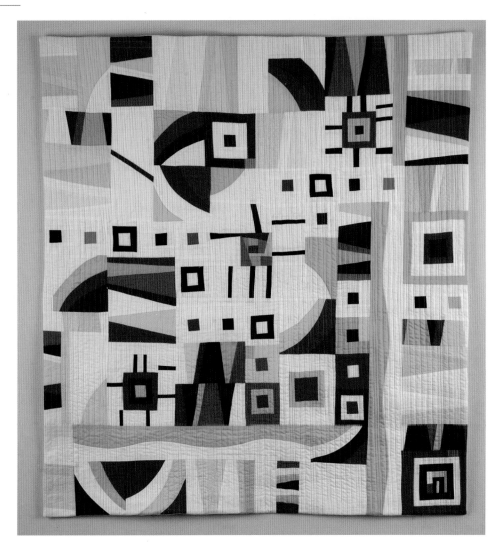

Picasso's Chickens
40 × 37 inches, 2020

Materials in play

My materials are simple: fabric and thread. About 10 years ago, I stopped using commercial prints and switched to only solid fabrics in order to better showcase stitched texture. On solid fabrics, the stitching becomes an integral part of the artistry of a piece, not just a way to hold the piece together. It was scary at first, because there was nowhere to hide if the stitches didn't look right.

My family teases me a lot about being a rule follower. If the sign says "Don't walk on the grass," I don't do it. But I don't follow the rules when I'm cooking or when I'm quilting. I want to see what happens if I make my own rules!

Since I work without a pattern, there is almost always a point with each quilt when I just don't know where to go next. I know it's going to happen and I expect it. I think there's a common misconception that Improv is a quick process, and it really isn't. Most designs need to marinate for a period of time while I assess what needs to happen next. I take a lot of photos as I create, which helps to see where the problem areas might be. And I ask "What if?" as I audition new colors, new lines, and new shapes until I have a composition that sings to me. *Picasso's Chickens* was a good example. It went through many versions as I edited the color choices and placement of the different elements over a period of weeks.

Finding inspiration

One of my main inspirations is color, and I enjoy trying different color combinations to see how they interact. Even though my work is abstract, buildings and landscapes inspire me with their interesting lines and shapes. My home studio looks out on a lake, and its appearance is ever changing as the lake takes its cues from the weather and the seasons to provide endless inspiration.

I'm also inspired by the nature of improvisation itself. There are no rules except the ones I set, and I never know what the finished piece will look like as I begin. That can be intimidating but also exciting. There's always something new to explore. Cutting directly into fabric, using my rotary cutter as a drawing tool, engages me in a dialogue with my materials that allows my creativity to run free.

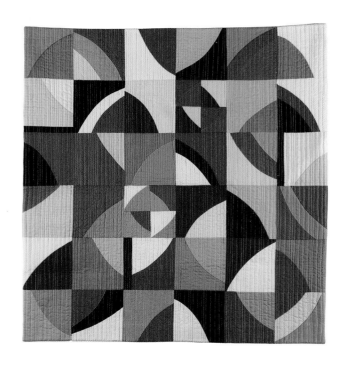

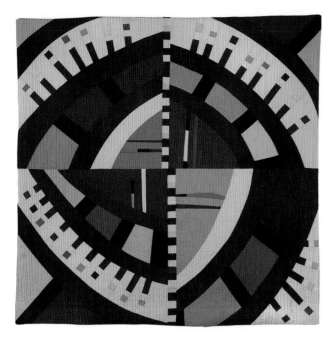

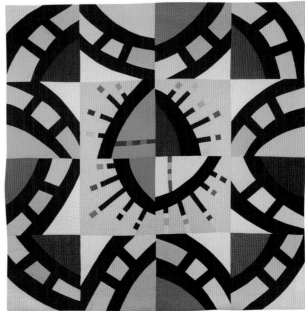

Above left:
Confetti
46 × 46 inches, 2018

Above right:
Kaleidoscope
57 × 57 inches, 2018

Left, clockwise from top left:

Green Shoots
50 × 40 inches, 2021

Taste of Summer
50 × 40 inches, 2021

Neon Fizz
32 × 32 inches, 2019

Learning and teaching

Teaching is an unexpected joy. I'm an introvert, so I wasn't sure how I would like standing in front of a group to lecture and teach. After spending nearly 10 years traveling throughout the United States showing and selling my work at fine art and craft shows, I wrote *Artful Improv: Explore Color Recipes, Building Blocks & Free Motion Quilting* for C&T Publishing. I realized it's not so hard to talk about something I love. My students ask great questions, pushing me to find answers and often pointing me in new directions. In order to teach a technique, you have to know it inside and out and be able to troubleshoot any problems that arise. Delving into improvisation in order to teach keeps my work fresh.

What lies ahead

I have a new series of work that explores large freehand cut curves and focuses on creating interesting lines and shapes with the juxtaposition of color, like *Green Shoots* and *Taste of Summer*. I am also continuing to work on new on-demand classes for individual students to take on their own schedules and live online classes intended for guilds and groups.

My new book, *Adventures in Improv Quilts: Master Color, Design & Construction* from C&T Publishing, was a lot of fun to write, and I'm looking forward to sharing some new ideas about making improv quilts without patterns or templates.

cindygrisdela.com

Intimate Portraits

Linda Anderson
La Mesa, California, USA
laartquilts.com
Consuelo
47 × 54 inches (119 × 137 cm), 2019
Photo: Eric Mindling

Geneviève Attinger
Arradon, Morbihan, France
attinger-art-textile.odexpo.com
Penn Sardin-La Dentellière
62 × 32 inches (156 × 80 cm), 2017

Jackie Houston
Oakland, California, USA
Life Is Precious
27 × 21 inches (67 × 52 cm), 2019
Photo: Linda Meas

Susan Callahan
Silver Spring, Maryland, USA
Susancallahanart@woodpress.com
Portrait of a Chef
45 × 104 inches (114 × 264 cm), 2019
Photo: Eric REiffenstein

Sandra Bruce
Grass Valley, California, USA
sandrabruce.com
Yayoi
50 × 30 inches (127 × 76 cm), 2019

Patty Kennedy-Zafred
Murrysville, Pennsylvania, USA
pattykz.com
American Portraits: Heart of the Home
57 × 68 inches (145 × 173 cm), 2019
Photo: Larry Berman

Linda Filby-Fisher
Overland Park, Kansas, USA
lindafilby-fisher.com
Unity 10 Medicine Wheel series
20 × 10 × 0.75 inches (51 × 25 × 1.9 cm), 2015

Fuzzy Mall
Dundas, Ontario, Canada
quiltedportrait.net
Aleef Mehdi
86 × 46 inches (218 × 117 cm), 2020

Kathleen A. McCabe
Coronado, California, USA
kathleenmccabecoronado.com
Mothers and Daughters
42 × 33 inches (107 × 84 cm), 2020
Photo: Phil Imming

Kim H. Ritter
Houston, Texas, USA
Cowgirl and Alien
44 × 64 inches (112 × 163 cm), 201

Kathryn Pellman
Los Angeles, California, USA
kathrynpellman.com
It's My Birthday Again!
30 × 26 inches (76 × 65 cm), 2020
Photo: Johanna Wissler

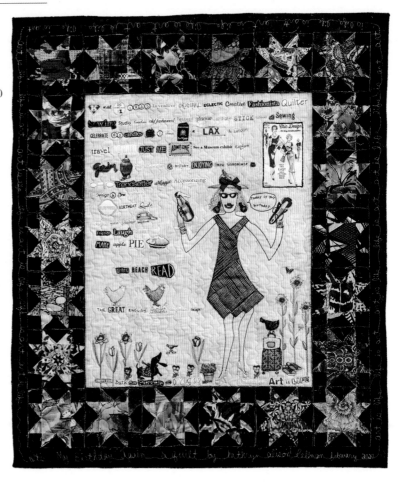

Sherri Culver
Portland, Oregon, USA
sherriquilts.com
Just Don't Touch My Dad's Tools . . .
21 × 50 inches (53 × 127 cm), 2018
Private collection. Photo: Hoddick Photography

Valerie Cecilia White
Denver, Colorado, USA
valeriecwhite.com
Sweet Solitude
31 × 38 inches (79 × 97 cm), 2020
Private collection. Photo: Wes Magyar

Valerie Wilson
Winnipeg, Manitoba, Canada
valeriewilsonartist.com
The Hockey Boys
66 × 42 inches (166 × 107 cm), 2019

Susan Lenz
Columbia, South Carolina, USA
susanlenz.com
Oswald Home Laundry
44 × 61 inches (112 × 155 cm), 2020

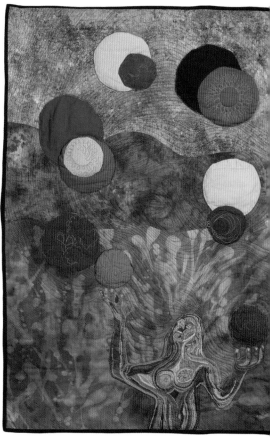

Daniela Tiger
Toronto, Ontario, Canada
danielatiger.blogspot.com
An Autobiography
43 × 29 inches (109 × 74 cm), 2015
Private collection. Photo: Sylvia Galbraith

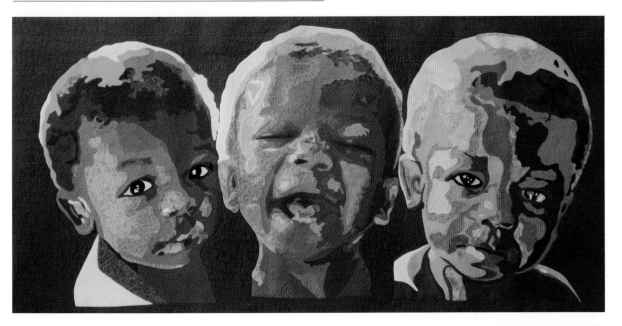

Sandy Curran
Newport News, Virginia, USA
sandycurran.com
Sweet Innocence
33 × 67 inches (84 × 170 cm), 2019

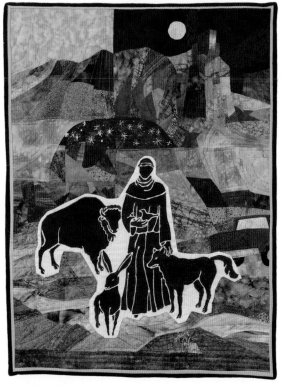

Ellie Kreneck
Lubbock, Texas, USA
kreneckstudios.com
St. Francis spotted in West Texas
38 × 28 inches (97 × 71 cm), 2020

Sandra Sider
Bronx, New York, USA
sandrasider.com
"Right Is of No Sex, Truth Is of No Color":
Frederick Douglass and the 1848 Declaration of Sentiments
55 × 41 inches (140 × 104 cm), 2020
Photo: Deidre Adams

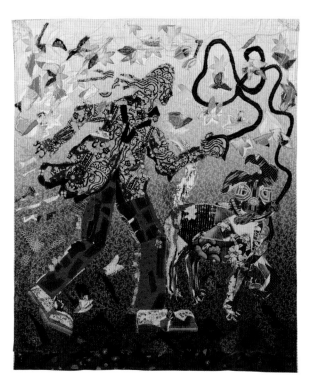

Jim Hay
Takasaki, Gunma, Japan
jim-hay-artist.com
Comes The Wind
46 × 38 inches (117 × 97 cm), 2020

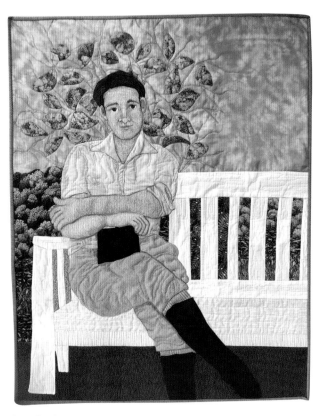

Lora Rocke
Lincoln, Nebraska, USA
The Correspondent
42 × 27 inches (107 × 69 cm), 2020

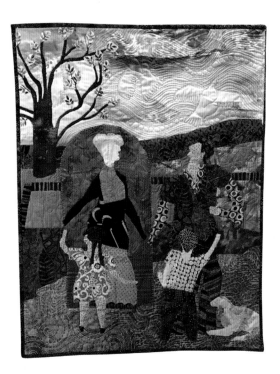

Pamela Allen
Kingston, Ontario, Canada
pamelart.homestead.com
Family Flying a Kite
32 × 26 inches (81 × 66 cm), 2019

Caryl Bryer Fallert-Gentry
Port Townsend, Washington, USA
bryerpatch.com
Hanging at the Pompidou
40 × 44 inches (102 × 112 cm), 2019
Private collection

Maggie Dillon
Sarasota, Florida, USA
maggiedillondesigns.com
Summer Tomatoes
37 × 48 inches (94 × 122 cm), 2019
Private collection

Kathleen Kastles
Wailuku, Hawaii, USA
Stroller
29 × 22 inches (74 × 56 cm), 2017
Collection of Bob and Tess Cartwright. Photo: Xinia Productions,
José Morales

Virginia Greaves
Roswell. Georgia. USA
virginiagreaves.com
Mistr Men
35 × 58 inches (89 × 147 cm). 2019
Private collection

Sherry Davis Kleinman
Pacific Palisades, California, USA
A Moment in Time with Genevieve
30 × 27 inches (76 × 69 cm), 2019
Photo: Steven Kleinman

Denise A. Currier
Mesa, Arizona, USA
deniseacurrier.com
Humor Has It
30 × 24 inches (76 × 61 cm), 2016
Rendition of public domain image photo: Orig. photographer Allan
Warren, "Phyllis Diller," 1973, Wikimedia Commons Creative
Commons License Deed—Licensed under CC BY-SA 3.0 via
Commons

Sarah Ann Smith
Hope, Maine, USA
SarahAnnSmith.com
His Immensitude, Yoda, Emperor of Minions and All He Surveys
20 × 20 inches (51 × 51 cm), 2019

Pixeladies
Cameron Park, California, USA
pixeladies.com
Katharine McCormick: Making her Mark
38 × 36 × 2 inches (97 × 91 × 5 cm), 2019

Ruth Powers
Carbondale, Kansas, USA
ruthpowersartquilts.com
Who, Me?
30 × 34 inches (76 × 86 cm), 2012
Private collection

Bonnie Peterson

HOUGHTON, MICHIGAN

Road to art quilts

Photos: Tom Van Eynde

My work follows the trajectory of my life experiences, including family, human rights, outdoor adventures, and environmental science. When I was in my 30s and home with young children, I lost a close friend to breast cancer. I stitched bras, her poetry, and related news items into a wall hanging. Breast cancer was a taboo conversation topic in the early 1990s, but at an exhibition I observed people laugh at the bras and share their own experiences. It was a source of satisfaction for me to encourage this discussion. Grants from the Illinois Arts Council Agency encouraged me to create art quilts concerned with personal, social, and political themes.

Glorious inspiration

I grew up near Chicago and was introduced to the Sierra Nevada mountains in my early 20s by a coworker who took me to Mount Whitney. We took the mountaineer's route, and I have backpacked in this region ever since. The works I created for my exhibition *Another Glorious Sierra Day* [at the Fresno Art Museum] relate to my wilderness experiences, Sierra history, science, and culture. An artist residency at Yosemite National Park motivated several works that incorporate melting data from Yosemite's Lyell Glacier.

In addition to Yosemite, National Park Service artist residencies led me to investigate the history and trails of Rocky Mountain, Crater Lake, and Isle Royale National Parks. The residencies are a time for research and design, supported by knowledgeable park rangers.

Anthropocene
23 × 27 inches. 2021

The messages

My recent projects examine geophysical climate issues. I started making climate graphs during an artist-scientist project sponsored by University of Wisconsin. Another project, *Fires of Change*, was an artist-scientist project funded by the National Endowment for the Arts and initiated by the Flagstaff Arts Council. It explores how fire as an ecosystem process is affected by climate change and encroaching development. This project involved a week of training with fire scientists and land managers on the impacts of wildfires at the Grand Canyon. My work for this project illustrated environmental factors in fire ecology through an embroidered relationship map.

Days of Lead sprang from an invitation to create a 12-inch square for a Lansing, Michigan, community quilt. Lead had been discovered in the Flint, Michigan, water supply. I researched the issue and grew so alarmed by the situation that I composed a large work that told about obfuscation by public servants and the citizen science that brought the lead poisoning to light.

I am interested in atmospheric science and the instruments that measure ocean temperatures, currents, Arctic sea ice, and other environmental properties. I combine this contemporary data with text from the rich history of 19th- and 20th-century exploration. I hope my work encourages critical thinking through the use of unusual textures, design, and narrative.

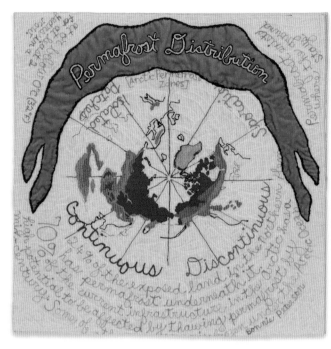

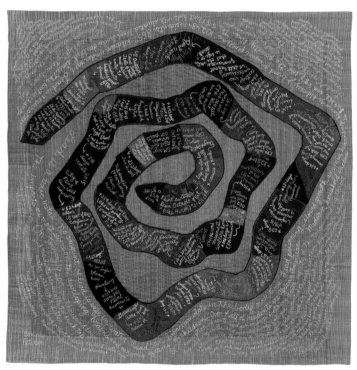

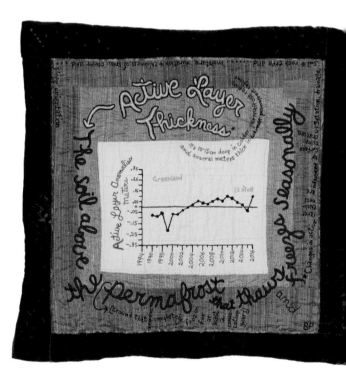

Insect Apocalypse
25 × 23 inches, 2021

Permafrost Distribution
16 × 16 inches, 2021

Days of Lead
50 × 50 inches, 2017

Permafrost Active Layer
25 × 25 inches, 2021

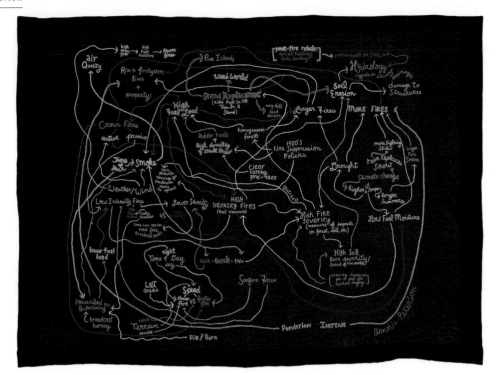

The process

Silk and velvet fabrics are the base materials for my work, and text is the most important element. In early work, I added text through dye or heat transfer. Now, I use free-motion or hand embroidery to add words and graphs. By hand, I add crazy-quilt stitches and other distinctive marks with wool, silk, rayon, cotton, and polyester threads. Much of my basic assembly is also done by hand.

My work requires a lengthy research phase. Over a period of literally years, I collect and organize concepts and materials for a number of topics. For example, I continue to read current research in fire ecology, and I enjoy a weekly fire science seminar series with professors and fire ecologists from around the country.

Routine and exercise are important to me. I work in the studio before and after a couple of hours of cross-country skiing or road cycling. Up here near Lake Superior, that's right out the door! My work in the studio then continues the rest of the day and into the evening.

What's next?

I am always looking for opportunities that bring together artists and scientists. Currently, I am working on a series of permafrost works for a show at the Peggy Notebaert Nature Museum in Chicago. Permafrost is a broad topic. As the climate warms, it's an increasingly important aspect of climate science. Two of my new works on permafrost are *Permafrost Active Layer* and *Permafrost Distribution*.

www.bonniepeterson.com

Wen Redmond

STRAFFORD, NEW HAMPSHIRE

Finding my voice

Quilting fiber constructions and photography have long been parallel passions. My game-changing moment came when I was able to use a computer to print my own photos onto cloth. My work exploded! The process combines both of my artistic expressions.

I first shared my techniques in 2007 with an article on holographic imagery published in *Quilting Arts* magazine. I was also invited by the company to do an instructional video on my process and to appear on Quilting Arts TV.

I think as artists we become quite passionate about our work, and we work all the time. We are usually always taking things in, whether or not it is actually conscious. The light of a day, the pattern on a car, the arrangement of trees, and invisible things too. The emotions of a fine movie, the quiet feeling one gets after a thoughtfully wrought poem, the sight of people greeting each other at airports after a journey from home. These things become even more precious and tender the older one gets. They are gifts.

Techniques and process

My fascination with photography is expressed through printing manipulated original photographs directly onto various substrates and specially treated natural fibers. This approach makes materials a fundamental aspect of my current explorations. I print on recycled or unusual materials to give unique and ever-more-interesting results than can be achieved with simple paper or fabric alone. I consider what image would print best on various surfaces, such as tea bag liners, foil, or molding paste. Will the image blend or stand out?

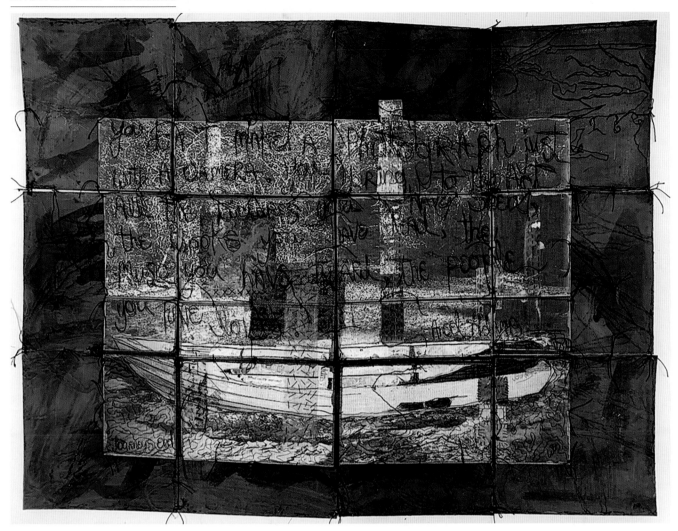

Above:
Journeys End
16 × 34 inches, 2021

Right:
Intertwined
17 × 29 inches, 2018

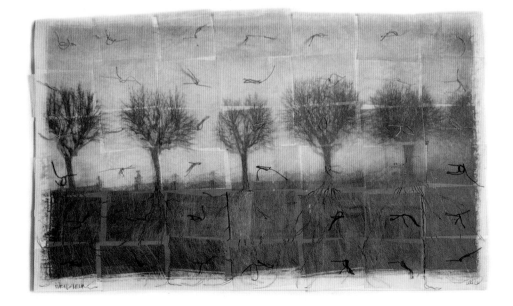

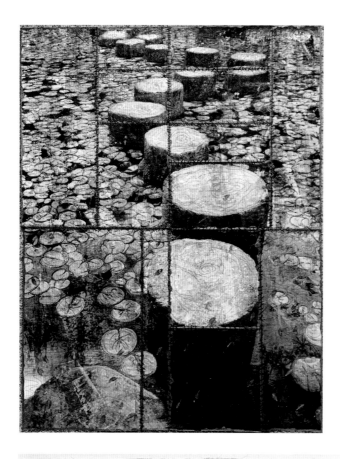

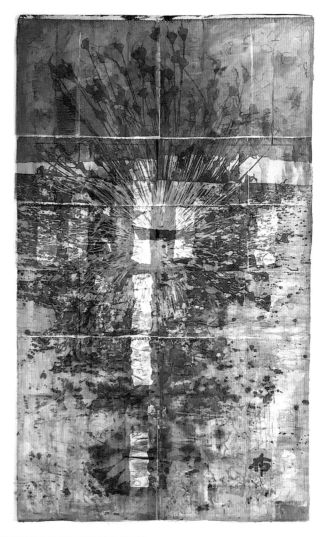

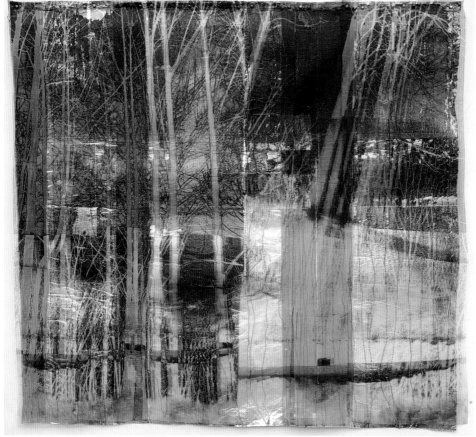

Clockwise, from top left:

Stepping Stones
42 × 32 inches. 2020

Layers of Meaning
50 × 30 inches. 2020

Drawing a Breath
22 × 24 inches. 2019

When a piece isn't working well, I generally put it aside for a while. I find that allows for ideas to surface. I often work on more than one piece at a time, or I make small 6-by-6- and 12-by-12-inch works that provide me with smaller spaces to experiment with. I adore trying new things, mixing fiber work with the addition of paper and recycled items. I have tried many mediums both to print onto or to add to finished work. Some of these techniques can be found in my book, *Wen Redmond's Digital Fiber Art: Combine Photos & Fabric, Create Your Own Mixed-Media Masterpiece* (C&T Publishing).

I am currently uploading small videos that highlight techniques in my book, Digital Fiber Art and Other Mixed Media Surfaces, on YouTube!

Recent projects

A recent work, *Drawing a Breath*, was printed on an undercollage created from flashing and duct tape, using interfacing as the base. Drawn lines were sewn with thread and then an overlay was created with the same image printed on silk organza, attached at the top with brads. The organza floats away as people walk by, creating a sense of breath.

During a visit to Japan, I took a photograph at the Temple of the Golden Pavilion (Kinkakuji) in Kyoto. The garden complex is an excellent example of Muromachi-period garden design, a classical age of Japanese garden design. The photograph was fused digitally with another photo of my hand-painted fabrics. The combination of technique parallels the emotional fusing that Japan wrought on my being; it became *Stepping Stones* into my heart.

A new piece, *Layers of Meaning*, is my way of expressing the idea that art is a journey, symbolized in a layered manipulated image of a lone boat crossing a lake, a Queen Anne's lace blossom, and painted fabrics for color. This is printed on silk organza that floats, like the boat and seeds in the air, to be caught, perchance to land.

Style defined

My style is eclectic, experimental, and known for breaking rules. I expose people to new ways of seeing. I also strive to inspire. Art, to me, is about moving forward. Creation gives me ideas. My passion is to put them into art through my desire to create.

I think growth is part of my process—not that every technique out there should be embraced, but I believe that growth is essential for an artist. I continue to explore types of presentations, different substrates, and different ways of constructing that fit me best at any given time in my career. Digital fiber has had the greatest hold on my creative pursuits. It includes everything I have learned: sewing by hand and machine, quilting, surface design, painting, the use of all sorts of mediums, collage, photography, and all the new 21st-century digital tools.

Quilts and Culture: The Uniquely American Story of the Renwick Gallery Collection

JAIMIANNE JACOBIN

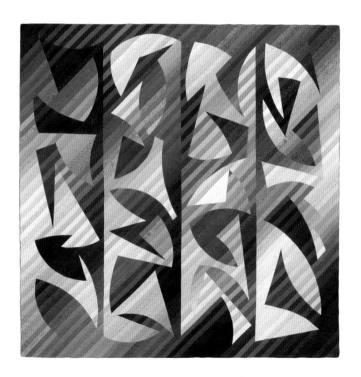

Michael James
Quilt #150: Rehoboth Meander
53 × 52.5 inches, 1993
Smithsonian American Art Museum, 1994.76

Located across from the White House in the national capital, the Renwick Gallery is in many ways the craft museum of the United States. The gallery opened its doors in 1972, just three years after the hallmark traveling exhibition of fine craft *Objects USA* debuted in Washington, DC. Lloyd Herman served as the founding director of the building "dedicated to art," as self-proclaimed by the etched insignia located above the front steps of the building. The Renwick's collection is separate but shared with the Smithsonian American Art Museum. Together, they hold more than 40 art quilts that tell a uniquely American story.

In addition to contemporary works, there are approximately 70 unidentified early folk-art quilts in the collections. *Melrose Quilt* (1960, not pictured), a pictorial piece by Clementine Hunter, is arguably one of the earliest "art quilts" that bridges the distinction of folk and fine art. Hunter was a cotton picker and self-taught artist at Melrose Plantation in Louisiana, a mecca for freed Black artists and writers. Her paintings and quilts document her experience and authenticate her as the first African American artist to have a solo exhibition at the New Orleans Museum of Art.

The earliest quilt exhibition at the Renwick Gallery, *American Pieced Quilts* (1972), was curated by Jonathan Holstein, who, with his late wife, Gail van

Joan Schulze
The Crossing
57.25 × 43 inches, 1990
Smithsonian American Art Museum. Gift of
Penny Nii and Edward A. Feigenbaum, 1997.

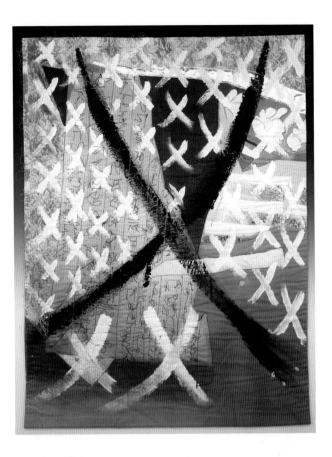

der Hoof, was responsible for the pivotal exhibition *Abstract Design in American Quilts* at the Whitney Museum of American Art in 1971. Holstein's quilt collection would inspire Michael James, a pioneer of the early Art Quilt Movement, and author of the book The Quiltmaker's Handbook: A Guide to Design and Construction. His *Quilt #150: Rehoboth Meander* (1993) was created during a period in his work when he was moving away from the traditional grid format and exploring less predictable ways to structure a quilt's surface.

Nancy Crow, a cofounder of Quilt National, Quilt Surface Design Symposium, and a leading figure in the development of the Art Quilt Movement since the 1970s, was the first to premiere a solo exhibition of art quilts at the Renwick Gallery in 1995. The exhibit *Nancy Crow: Improvisational Quilts* included 40 works and had an accompanying catalog. Her piece *Crucifixion* (1977, not pictured) was later acquired in 2002 by the gallery.

It was not until 1986 that *The Art Quilt*, a traveling exhibition, officially coined the term for this art form. Joan Schulze was one of the artists included in the show. Her work in the Renwick collection, *The Crossing* (1990), was painted, pieced, appliquéd, and machine-quilted with stitched calligraphy. Art quilts in the 1980s were defined by the proliferation of new ideas, experimentation, and a new perspective. Carolyn Mazloomi famously founded the Women of Color Quilter's Network in 1986. Her work *The Family Embraces* (1997, not pictured) is just one of her many meticulously stitched narratives of African American heritage.

In 1989, Yvonne Porcella founded Studio Art Quilt Associates. The first art quilt she created, *Takoage* (1980), inspired by the artists and energy of the West Coast art quilt community, now resides in the Renwick collection.

The 1990s were an exciting decade for art quilts at the Renwick Gallery. In 1995, *Full Deck: Art Quilts* exhibited at the Renwick Gallery and included 54

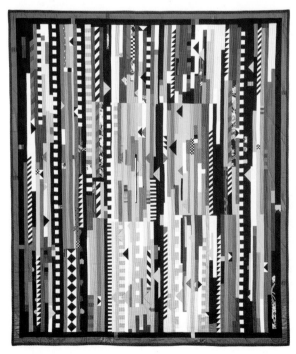

Yvonne Porcella
Takoage
82.5 × 71.5 inches, 1980
Smithsonian American Art Museum. Museum purchase
through the Smithsonian Institution Collections Acquisition
Program, 1995.15.

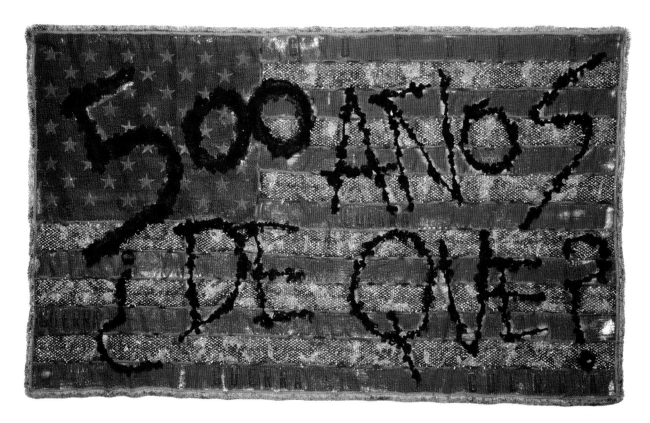

Arturo Alonzo Sandoval
¡Guerra!
58 × 96 × 0.75 inches, 1992
Smithsonian American Art Museum, Gift of the James Renwick
Alliance, 1999.42.

quilted playing cards. The traveling show, conceived by quilt artist Sue Pierce, was organized by SITES, the Smithsonian Institution Traveling Exhibition Service. In part because of the accessible subject matter and because of the popularity of quilting, the exhibition was a blockbuster show, drawing huge crowds and traveling across the United States for almost two decades.

Quilts acquired at this time portray sociopolitical issues through the lens of the artist. One example is *¡Guerra!* by Arturo Alonzo Sandoval, a Hispanic and Native American artist who served in the Vietnam War. His piece depicts the American flag in blood red and includes a mesh containing hundreds of plastic skeletons. The words "500 años ¿De Que?" or "500 Years, Of What?" are stitched across the front with "war" printed in Spanish. Another piece, *Virgen de los Caminos*, or *Virgin of the Highways*, is a heartbreaking piece by Chicana artist Consuelo Jiménez Underwood. In her work, the Virgin Mary stands dead in the center of the quilt, with barbed wire embroidered across it. Quilted in the background

is a depiction of a freeway crossing sign like those erected to prevent people from being killed by cars crossing the Mexican-American border.

Recent acquisitions address topics of gun violence, the recession, and gender stereotypes. One recent acquisition was *Washington, D.C. Foreclosure Quilt* (2015) by Kathryn Clark. Clark began to make her *Foreclosure Quilts* in 2007 to document the effects of the economic recession on the American landscape. By 2015, the mortgage crisis had faded from the news despite the ongoing distress of many homeowners, and Clark crafted this piece to keep the tragedy in the public eye.

By looking through the Renwick's art quilt collection, we see a story outlining two narratives. One account is about the history of the Art Quilt Movement. The other is individual American histories of trials and triumphs as uniquely told through the quilts. Together, these narratives form a diverse collection presenting a distinctly American view of contemporary culture through the artworks of the Renwick Gallery of the Smithsonian Art Museum.

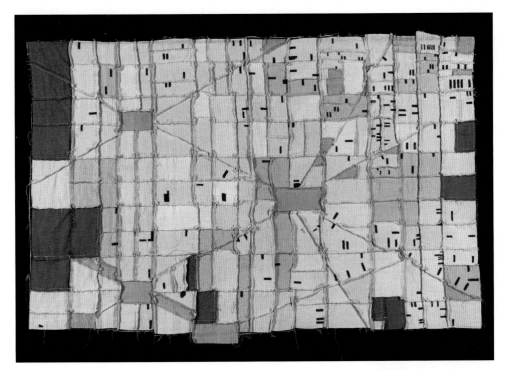

Kathryn Clark
Washington, D.C. Foreclosure Quilt
57.5 × 84.75 inches, 2015
Smithsonian American Art Museum, Museum purchase through the Stephen D. Thurston Memorial Fund, 2015.40.

Jaimianne Jacobin is the Director of James Renwick Alliance and the former Executive Officer of the Creative Crafts Council. The James Renwick Alliance celebrates and advances American craft by fostering education, connoisseurship, and public appreciation. In addition, the Alliance has supported a significant portion of the Renwick Gallery's collection by providing more than $3 million for acquisitions, exhibitions, public programs, and publications.

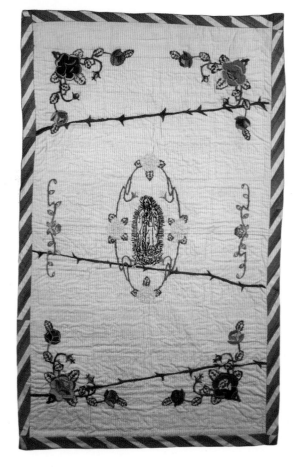

Consuelo Jiménez Underwood
Virgen de los Caminos
58 × 36 inches, 1994
Smithsonian American Art Museum, Museum purchase, 1996.77.

INTERVIEW WITH

Susan Rienzo

VERO BEACH, FLORIDA

Follow your heart

After exploring different directions to find my niche, I realized that the cliché "Follow your heart" really does matter. I accepted my quirkiness and refocused. Color blocking, abstract design, whimsical images, and playfulness define my style.

My work makes use of fusing, collage, raw-edged appliqué, painting, and mark making. I mainly use commercial fabrics, along with batiks and hand dyes. I also create and use my own ice-dyed, painted, and surface-design fabrics. I often free-cut my fabrics, intuitively choosing what's needed, but I love starting out with my scraps. Scraps offer surprises, and I obsessively save them down to 1 inch in size.

Finding inspiration

I am excited by saturated and vibrant color. A good starting point is fabric itself, but cues are to be found everywhere—the work of other artists, trends in fashion, typography, photography. I'm inspired by illustration styles, Indigenous designs, and colorful commercial products. My love for children's art and illustration started when I fell in love with the Richard Scarry books that I read to my kids when they were little. Illustrations for children are so full of joy, and I've always loved the expressive spirit of children's art.

My love for the beach and oceans is equally high on my inspiration list. I have happy memories of going to the beach as a child. My husband and I moved to Florida 16 years ago, and I enjoy sharing whimsical beach themes with viewers. Sunsets and sunrises are also part of my work.

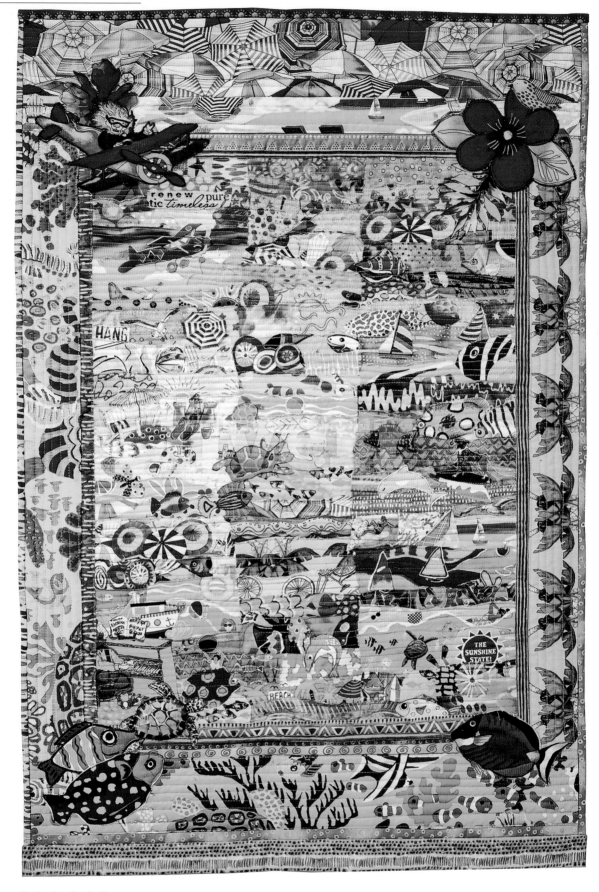

By the Sea, By the Sea
36 × 24 inches, 2019

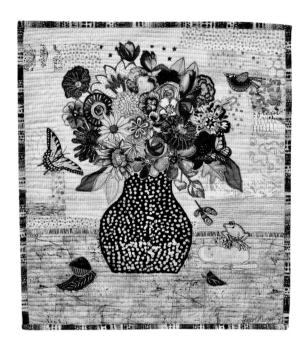
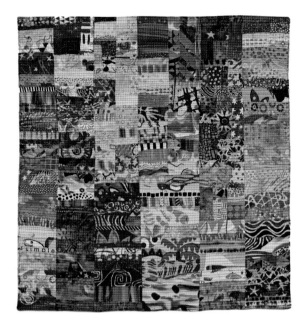

Art making

I am not structured when I create. I discovered I create better when I work intu-itively. In my 20s, I saw an exhibition of Louise Nevelson's monumental sculptures. I was inspired by her composites of found elements, which I found quite quilt-like. Reading her biography years later, I was inspired by how she struggled and created, gathering found objects for her art. And isn't gathering and collecting the source of quilt making? For me, how to merge disparate design elements took a lot of introspection and time. Now my colorful quirkiness has given me my distinct style and is very rewarding.

My process to create new work used to involve sketching out ideas, but it has progressed to improvisational piecing, collage, and being more spontaneous. I select and fussy-cut whimsical illustrations from novelty fabrics and include them in my designs.

When I get stuck, I let the piece stay on my design wall so I can keep looking at it and try to figure out why it is not working. If something is sticking out or appears to grab too much attention, I will make some changes in either the fabric pieces, or the colors used. I ask questions to find out what is bothering me about the piece. I will also analyze if there is a problem with the composition. Moving things around and answering these questions often helps. I try to stay engaged with the piece so I keep my focus on it so I am motivated to finish it, asking myself, what do I love about this piece?

I try to keep the critical voices in my head at bay and keep the positive vibes. I have to be careful of falling into the fear of finishing it. If I like a piece too much, I am often afraid of ruining it and go into a freeze mode. It may languish in my to-do pile while I start new projects. I keep it front and center so I can let myself get mad enough to say: "Get it done; just do it!" An ongoing creative battle.

Above left:
Always for You
20 × 18 inches. 2019

Above right:
Sunset Visions
21.5 × 20 inches. 2021

Florida Spirits
32 × 31 inches, 2020

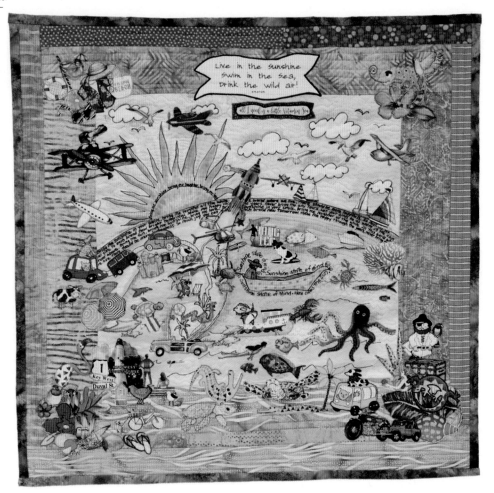

What's ahead?

In the past few years, I have stepped slowly into teaching locally. Teaching is a new adventure for me, and I was surprised at how much I love to share what I do. I find it very rewarding, and I look forward to more teaching opportunities.

After working on *Florida Spirits* for the SAQA's *Floridian Flavors* exhibit, I took a much-needed break. Back to my studio time, I recently finished a small piece called *Sunset Visions 2021*, continuing my explorations in juxtaposition in color and pattern, created improvisationally with creative thoughts of when life can get back to normal. And I was delighted that *Sunset Visions* was accepted to *Color 2021* in Fort Collins, Colorado.

Now I am being drawn to create large again and experimenting with new color palettes and surface design. I am always bombarded with new ideas that I want to try. I have to continually work at reining myself in to focus on what's at hand. The fun is in the discovery. The best compliment I get is that my work is very happy and joyful. This is an affirmation to me that I am succeeding in what I wish to express.

www.susanrienzodesigns.com

Helena Scheffer

MONTREAL, QUEBEC, CANADA

Photo: Lauma Cenne

World of color

I love to work with color and consider myself a colorist, which is evident in my *Colour Explosions* series. This series arose out of monochromatic quilts I made from hundreds of squares and rectangles. At the time I owned an art gallery and was curating a show called *Red Alert*. There was a 40-inch size limit on the entries, which meant that a larger piece I had created wasn't eligible.

I decided to try a new approach. What if, instead of seaming together squares and rectangles, I collaged them onto a background? I decided to attach the resulting quilt to a painted canvas. The *Colour Explosions* series was born. Since then, I have made dozens of pieces in this series, from small 6-inch-square collages to what I consider to be my masterpiece to date: *Kilauea*, which measures 70 by 86 inches. It won Best of Show at the 2018 Chicago International Quilt Festival.

My process for this series involves placing hundreds of small pieces on a felt or batting background. The work is then covered with tulle before being heavily quilted and mounted on a painted canvas.

Colorful process

My *Colour Explosions* series is ongoing. I could create a new red piece every day. Red is a constant source of inspiration for me, but sometimes I deliberately choose a color that I find challenging, to see what I can do with it. I start each new piece with a basic color in mind and let the fabric determine the direction of the flow. This process can lead to surprises.

I have a large collection of vintage damask tablecloths and napkins that I dye, overdye, print, and otherwise manipulate. I love the texture of the woven fabric, which takes the dye so beautifully. I also buy commercial fabrics and browse thrift stores for old silk blouses, ties, and scarves. I find areas that work tonally and cut out small pieces measuring about an inch; the fabrics end up looking like Swiss cheese.

Photos by Maria Korab-Laskowska unless otherwise indicated

Kilauea
70 × 86 inches, 2018

Another part of the process that I enjoy is machine quilting. For me, this is what differentiates an art quilt from a painting: the three-dimensional aspect of the textile created by the stitching. I sit down at the machine and let my fingers fly. Nothing is planned; it just flows out of my fingertips. I also add hand stitching to many pieces, using thicker thread to add more texture.

Recently, a fellow artist friend gave me a small circular wooden panel and said, "Helena, I bet this would work well for your work." It was like a lightbulb turned on! I now love creating round artworks and so far have created nearly a dozen in different sizes.

Light of a Thousand Suns
36 × 36 inches. 2021

Temperature Rising
36 × 36 inches. 2019

Moving Toward Enlightenment
36 × 36 inches. 2021

Blood Moon
24 × 24 inches. 2018

Queen of the Night (made in
collaboration with Marion
Perrault)
42 × 41 inches, 2014

Art and beyond

Quite a few years ago, I was invited to do a trunk show and speak about my work
at a downtown library. Afterward, a woman raised her hand and said, "Your work
is so beautiful, it's almost like art." That comment cut me to the quick. Textile work
is art. I feel like I'm carrying the flag for textile art and its acceptance as fine art in
my community. I'm the only textile artist in my professional art association, Lakeshore
Artists. I exhibit twice yearly with this association and enjoy these opportunities to
educate the public about textile art.

During the pandemic, I started sewing masks for frontline healthcare workers,
along with other members of the quilting community. I personally produced about
1,500 masks. After the initial need was met in the hospitals and long-term-care
facilities, I was asked to continue to produce unique hand-dyed masks for local
retailers and galleries. This unexpected project became all consuming, and sur-
prisingly enjoyable. Dyeing fabric is a joyful process that I love: I am not very scientific
about it, and revel in totally unexpected results.

Aside from being an artist, I'm a dedicated yogi. After an intensive yoga
teacher-training program, I am now teaching a donation-based class on Zoom,
with all the proceeds going to charity. It's very time consuming, but I am learning
a lot and feel that I'm becoming a better human being along the way. In addition,
I've been invited to mount a solo show in a Montreal art gallery. I am now working
on a new series for this exhibition that will combine *Colour Explosions* with my
passion for yoga.

Surface Design

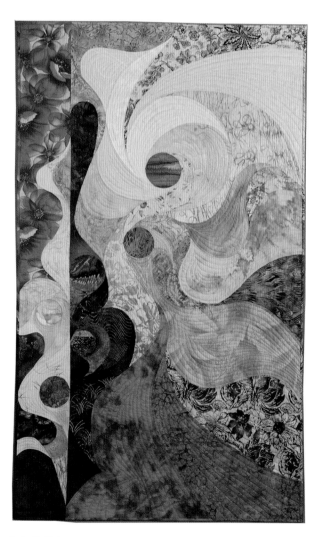

Judy B. Dales
Greensboro, Vermont, USA
judydales.com
Sunshine and Shadow
50 × 30 inches (127 × 76 cm), 2018

Jacque Davis
Freeburg, Illinois, USA
jacquedvis.com
Indigo Skin
44 × 21 inches (110 × 52 cm), 2017
Photo: Eric Jensen

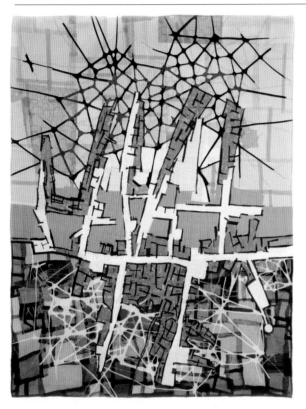

Sue Dennis
Brisbane, Queensland, Australia
suedennis.com
Mediterraneo-Buongiorno
32 × 34 inches (81 × 86 cm), 2019
Photo: Bob Dennis

Valerie S. Goodwin
Tallahassee, Florida, USA
valeriegoodwinart.com
Cartographic Collage II
48 × 36 inches, diptych (122 × 91 cm), 2017

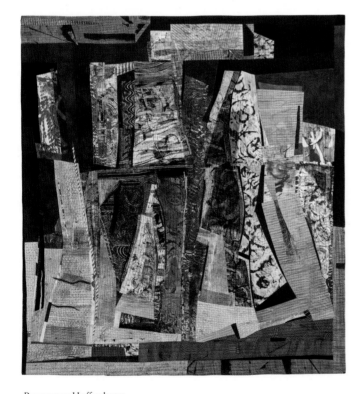

Randy Frost
Bronxville, New York, USA
Renewal X
26 × 36 inches (66 × 91 cm), 2018
Photo by Peter C. North

Rosemary Hoffenberg
Wrentham, Massachusetts, USA
rosemaryhoffenberg.com
Geisha
51 × 47 inches (130 × 119 cm), 2018
Photo: Joe Ofria

Floris Flam
Bethesda, Maryland, USA
florisflam.com
City Limits
13 × 19 inches (33 × 48 cm), 2017
Photo: Paul Seder

Pat Kroth
Verona, Wisconsin, USA
krothfiberart.com
Short Circuit
50 × 34 inches (127 × 86 cm), 2016
Photo: William Lemke

Judy Kirpich
Takoma Park, Maryland, USA
judykirpich.com
Indigo Compositions No. 10
88 × 41 inches (224 × 104 cm), 2020
Private collection. Photo: Mark Gulesian

Charlotte Ziebarth
Boulder, Colorado, USA
charlotteziebarth.com
White Nights: Seasonal Checkerboard Series #1
36 × 36 inches (91 × 91 cm), 2019
Photo: Ken Sanville

Elisabeth Nacenta-de la Croix
Collonges-Bellerive, Geneva, Switzerland
elisabethdelacroix.com
Maree Basse
49 × 31 inches (125 × 80 cm), 2020
Photo: Olivier Junod

Sue Reno
Bethel Park, Pennsylvania, USA
suereno.com
In Dreams I Saw the Rift
66 × 59 inches (168 × 150 cm), 2020

Dan Olfe
Julian, California, USA
Color Square #9
58 × 58 inches (147 × 147 cm), 2019

Jill Ault
Ann Arbor, Michigan, USA
jillault.com
No Crossbars
49 × 50 inches (124 × 127 cm), 2018

Catherine Whall Smith
Chaplin, Connecticut, USA
catherinewhallsmith.com
Blue Bloods: Transfusion 8
48 × 48 inches (122 × 122 cm), 2019
Private collection

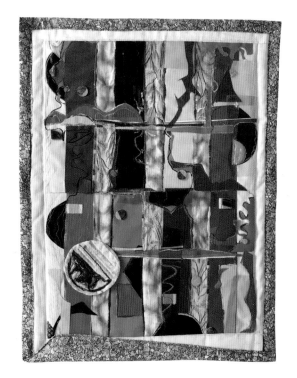

Ellen Deschatres
Vero Beach, Florida, USA
ellendeschatres.com
Off on a Tangent
21 × 20 inches (52 × 51 cm), 2008

Judith Quinn Garnett
Portland, Oregon, USA
blackdogdesignpdx.com
Correspondence with Hope
48 × 48 inches (122 × 122 cm), 2020
Photo: Sam Garnett

Michele Hardy
Silverthorne, Colorado, USA
michelehardy.com
Surfaces #22
45 × 36 inches (114 × 91 cm), 2018

Carole Harris
Detroit, Michigan, USA
charris-design.com
Time and Again
37 × 44 inches (94 × 110 cm), 2018
Photo: Eric Law

Julia E. Pfaff
Richmond, Virginia, USA
juliapfaffquilt.blogspot.com
Artifact 3.1
30 × 35 inches (77 × 89 cm), 2019
Photo: Taylor Dabney

Ann Johnston
Lake Oswego, Oregon, USA
annjohnston.net
The Contact: Arc Plumes
25 × 73 inches (64 × 185 cm),
2018
Private collection. Photo:
Aaron Jacobson

Susie Monday
Pipe Creek, Texas, USA
susiemonday.com
On the Day You Were Born: The Sun Flared
40 × 78 inches (102 × 198 cm), 2019
Photo: Ansen Seale

Joanne Alberda
Sioux Center, Iowa, USA
joannealberda.com
Tales from a Shingled Roof II
50 × 62 inches (127 × 157 cm), 2018

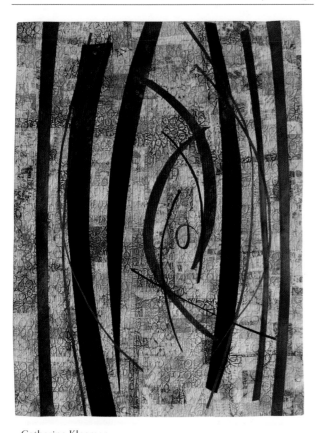

Catherine Kleeman
Ruxton, Maryland, USA
cathyquilts.com
Echoes
42 × 31 inches (105 × 79 cm), 2020

Alicia Merrett
Wells, Somerset, United Kingdom
aliciamerrett.co.uk
Quagma
47 × 26 inches (119 × 66 cm), 2019

Penny Mateer
Pittsburgh, Pennsylvania, USA
You Don't Own Me #14 Protest Series
60 × 60 inches (152 × 152 cm), 2018
Photo: Larry Berman

Paula Nadelstern
Bronx, New York, USA
paulanadelstern.com
Kaleidoscopic XLI: The Prague Spanish Synagogue Ceiling
79 × 64 inches (201 × 163 cm), 2018
Photo: Jean Vong

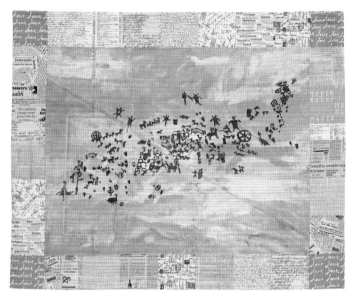

Maggie Vanderweit
Fergus, Ontario, Canada
stonethreads.ca
Written in Stone
43 × 52 inches (109 × 132 cm), 2019

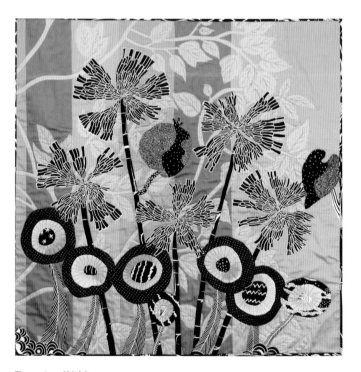

Terry Ann Waldron
Anaheim, California, USA
terrywaldron.com
Breezy
48 × 48 inches (122 × 122 cm), 2015

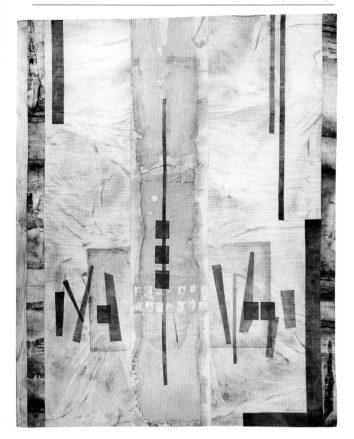

Peggy Brown
Nashville, Indiana, USA
peggybrownart.com
Along the Way
58 × 45 inches (147 × 114 cm), 2018

Benedicte Caneill
Larchmont, New York, USA
benedictecaneill.com
New Work, New York
47 × 47 inches (119 × 119 cm), 2019
Photo: Jean Wong

Linda Colsh
Middletown, Maryland, USA
lindacolsh.com
Fan Haiku 2
6 × 9 inches (15 × 23 cm), 2017
Photo: Ryan Stein Photography

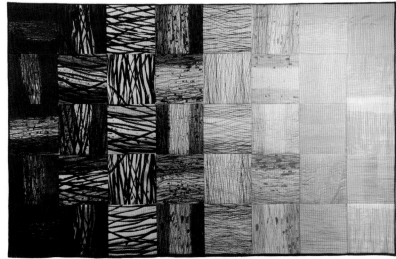

Judith Content
Palo Alto, California, USA
judithcontent.com
Resonance
48 × 75 inches (122 × 191 cm), 2019
Photo: James Dewrance

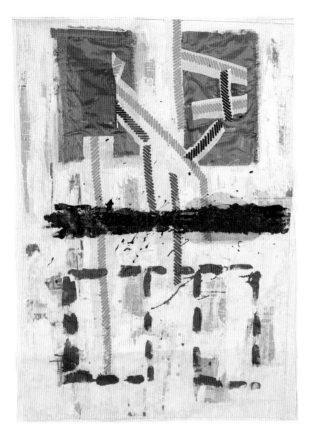

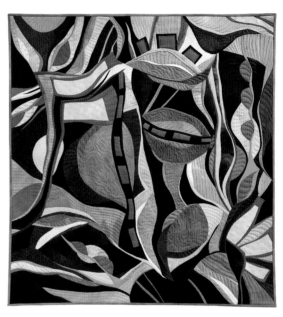

Yael David-Cohen
London, United Kingdom
yaeldc.co.uk
Train Map
55 × 39 inches (140 × 100 cm), 2019

Sheila Frampton-Cooper
Ventura, California, USA
zoombaby.com
Tangerine Dreams
26 × 24 inches (65 × 61 cm), 2018
Private collection

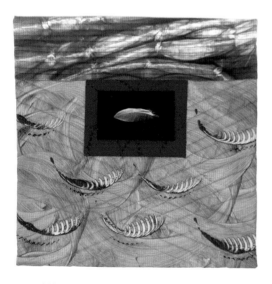

Gunnel Hag
Toronto, Ontario, Canada
colourvie.com
Watching the Tide Roll Away
12 × 12 inches (30 × 30 cm), 2019

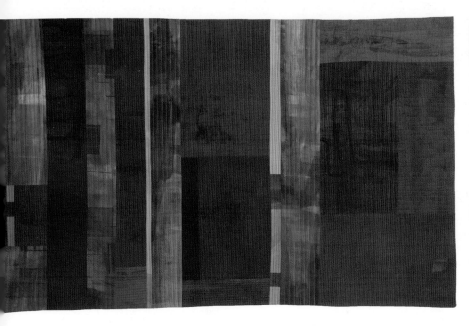

nelia Leigh
outhwick, West Sussex, United Kingdom
nelialeightextiles.co.uk
anquility
2 × 52 inches (81 × 132 cm), 2019
rivate collection. Photo: Katie Vandyke

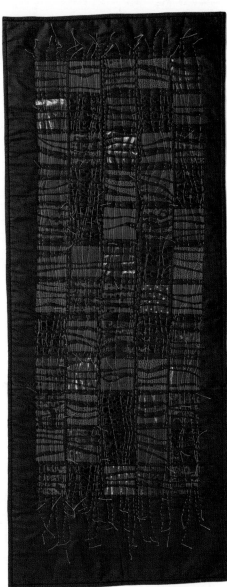

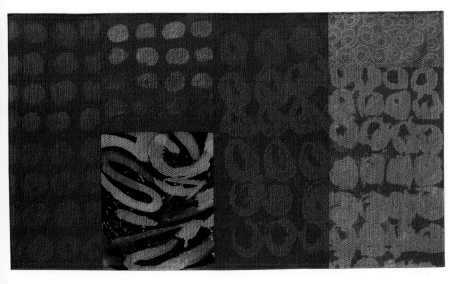

Alison Schwabe
Montevideo, Uruguay
alisonschwabe.com
About Red
39 × 24 inches (100 × 60 cm), 2014
Photo: Eduardo Baldizan

Judy Hooworth
Morisset, NSW, Australia
Adventure Journal: China
40 × 71 inches (102 × 180 cm), 2019
Private collection

Betty A. Hahn
Sun City, Arizona, USA
BoomBox
36 × 49 inches (91 × 124 cm), 2020

Jean Neblett
Santa Fe, New Mexico, USA
Reflections 18: On the Slough
39 × 40 inches (99 × 102 cm), 2004
Private collection. Photo: Sibila Savage

Hilde Morin
Portland, Oregon, USA
hildemorin.com
Tulip Envy
30 × 40 inches (76 × 102 cm), 2019

Karin Lusnak
Albany, California, USA
karinlusnak.com
Blue Attitude
55 × 44 inches (140 × 110 cm), 2020
Private collection. Photo: Sibila Savage

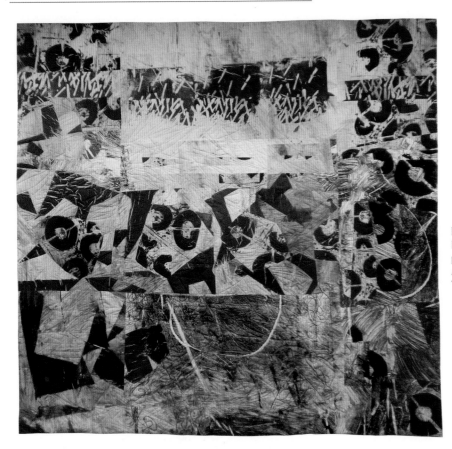

Pat Pauly
Rochester, New York, USA
patpauly.com
Bondi Beach
75 × 78 inches (191 × 198 cm), 2020

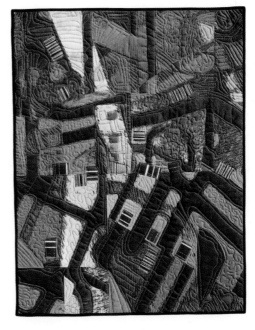

Hope Wilmarth
Spring, Texas, USA
hopewilmarth.com
Be Someone
40 × 40 inches (102 × 102 cm), 2017
Private collection. Photo: Rick Wells

Marian Zielinski
Macon, Georgia, USA
marianzielinski.com
Mapped and Coded
26 × 21 inches (66 × 52 cm), 2020

Sherri Lipman McCauley
Lakeway, Texas, USA
sherrilipmanmccauley.blogspot.com
Many Rounds
18 × 18 inches (46 × 46 cm), 2019

Elizabeth Michellod-Dutheil
Le Châble, Switzerland
elizabeth-michellod-dutheil.ch
Organic
55 × 37 inches (140 × 95 cm), 2018

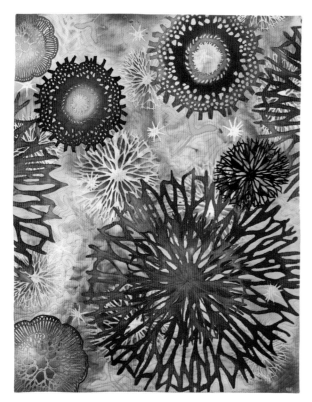

Sandy Gregg
Cambridge, Massachusetts, USA
sandygregg.com
Sparkle
44 × 23 inches (112 × 58 cm), 2019
Photo: Joe Ofria

Susan Rienzo
Vero Beach, Florida, USA
susanrienzodesigns.com
Take Two
34 × 30 inches (86 × 75 cm), 2018

Ludmila Aristova
Brooklyn, New York, USA
ludmilaaristova.com
Serenity
40 × 40 inches (102 × 102 cm), 2019
Photo: Jean Vong

Erika Carter
Berkeley, California, USA
erikagcarter.weebly.com
Weight of Wonder: Gold
42 × 42 inches (105 × 105 cm), 2019

Desiree Vaughn
Elk Rapids, Michigan, USA
Spring's First Breath
20 × 35 inches (50 × 90 cm), 2008

Sara Sharp

AUSTIN, TEXAS

Realistic approach

I have always been a "noticer," spotting the rare bird or seeing details in a scene that others miss. This trait goes hand in hand with a love of photography, and both characteristics explain why I often work in a realistic style. The images in my quilts are frequently based on my photos, which include images of animals, locales, and people. My husband and I own a cattle ranch outside Austin, where I find many subjects for quilts, including birds, insects, lizards, plants, horses, and cows.

One way I emphasize a work's focal points is by placing heavy thread painting in those areas. This technique requires time and patience, as hundreds of thread changes must be made to include all the colors needed for proper texture, detail, and shading.

I add interest to my quilts with textile paints, pencils, and inks. I use natural objects such as feathers and leaves to make direct prints or sun prints. I use my Epson printer or silkscreens to print my photos or copyright-free images. I especially enjoy creating complex fabric collages from scraps of batiks and commercial fabrics printed with small motifs; the different fabrics blend together like strokes in an impressionistic painting.

Process in play

The time needed to develop a working concept may be as long as the construction of the piece itself. I often fall asleep worrying how to configure a new quilt, only to wake the next morning with a clear composition in mind. I then make a final drawing and a full-size working pattern.

Winter Shadows
31 × 44 inches, 2019

I love the trial and error of auditioning fabrics, piling them up to see which ones work well together. I often choose the background fabrics first. I back the other fabrics with a lightweight fusible, cut out the pieces, and pin them down before ironing them in place. If focal areas are to be heavily thread-painted, I draw those images on a separate piece of fabric backed with stabilizer. When the thread painting is complete, those elements are trimmed and machine-appliquéd onto the quilt. Wool batting and a backing fabric are layered with the top, and I free-motion-quilt on my domestic Bernina sewing machine. Finishing the edges is the last step.

Since I work on one quilt at a time, I clean my entire studio when I finish a piece so that I can literally start from scratch on the next one.

My active mind approaches each quilt as a unique experience filled with new challenges to solve. My quilts fall into two categories: nature (animals, plants, and people) and narrative (emotions and social or political issues). There is some crossover. *Can We Save the Whooping Cranes?* references policies that protect wildlife. In the same way, the collage portrait of two little girls in *After the Party* explores how children handle their expectations and emotions.

I am continuing to work on new art quilts about birds and just returned from a trip to the Gulf coast to gather new images of shore birds. I am also working on my hand embroidery skills and using more hand stitching in my quilts.

After the Party
25 × 33 inches, 2017

Heron Loft
40 × 34 inches, 2019

*Can We Save the
Whooping Cranes?*
56 × 40 inches, 2014

Nurture
36 × 47 inches, 2018

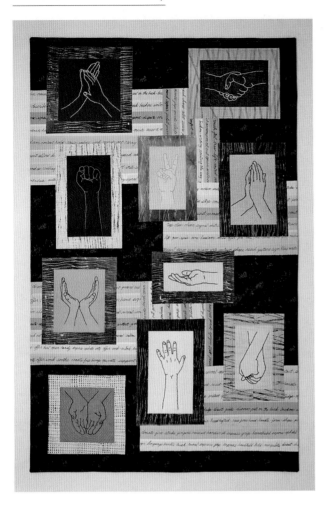

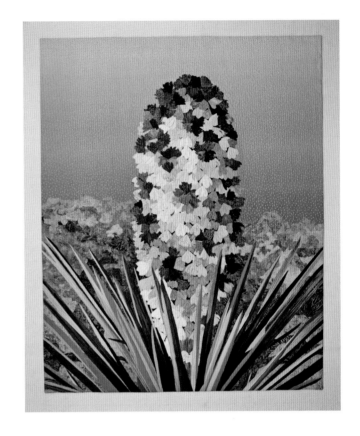

Above left:
Joining Hands
53 × 34 inches, 2020

Above right:
Yucca Bloom
46 × 38 inches, 2020

In the zone

I am so motivated to express myself through art quilts that I can't imagine not doing so. My mind is always filled with ideas to create new subjects, use different compositions, or try new techniques. My work has helped me cope with major health issues and pain, because when I'm in the zone creating, I feel healthy and happy.

If a piece is not going well, I try to take time off from working on it. I frequently gain fresh insights overnight during that period when I am very relaxed and almost asleep. Sometimes the solution idea is so stimulating that I have to jump out of bed and try it out!

I feel so fortunate that my quilts have been accepted into many juried exhibitions at large events and museums all over the world, and that people can buy my art from a local gallery. I have the added pleasure of friendship and support from local and worldwide members of SAQA. My desire is to do this work for as long as I am able.

sarasharp.com

Grietje van der Veen

THERWIL, SWITZERLAND

Photographic perspective

I've always been a passionate photographer, and I like taking photos on long walks. My favorite subjects are trees and their structures—bare trees in winter, all kinds of bark and roots, and scenes with trees aligned with brooks and rivers.

I took a course in digital photo processing, which led me to include photos and digital printing in my quilts. I processed my photos, printed them on fabric, and embroidered the fabric to create texture and to hide the seams, as I could print only standard A4-sized sheets.

Style evolution

My early nature quilts were realistic. In my tree quilts, I loved the depth induced, the shimmering light through the leaves, and the glittering water. My works about water were more abstract. In 2007, I started wrapping all kinds of cords with strips of used fabric and yarns to sew onto quilts. The technique started with the *Lamellibracchia* series after I saw an exhibition on deep-sea life at the Natural History Museum Basel. The exhibition included photos of creatures who live in absolute darkness. I wanted to express the overwhelming feelings I encountered by creating this series.

U-Tubes
Dimension varies (height
4 to 9 inches), 2019

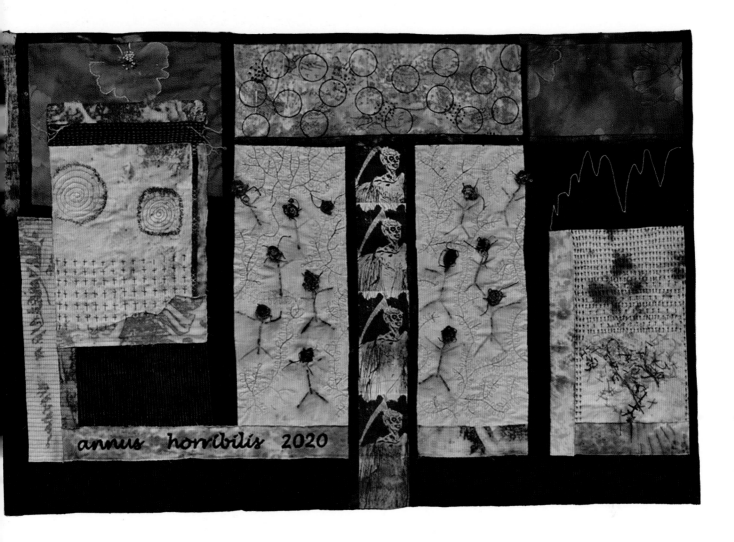

annus horribilis 2020
36 × 54 inches, 2021

Main messages

At the beginning of my career, I created work to please myself and my viewers. I did not feel the need to send a message to the world. I had a demanding job in a pharmaceutical plant, and quilting provided a distraction.

When I realized how rapidly our natural world is declining, I started my pollution series in 2014. To me, my quilts on abandoned mines are frightening. But as depicted in my quilts, the shockingly orange water that flows from these abandoned mines made a positive impression on the visitors who came to my latest exhibition. They didn't realize that the work has an protest aspect; they just thought it was beautiful. Maybe I was not drastic enough. It is an ongoing series.

My choice of materials makes another statement. The production of textiles involves an enormous amount of water and pesticides, and I believe that fiber artists ought to shoulder some of the responsibility for that situation. That's why I work exclusively with used, recycled textiles.

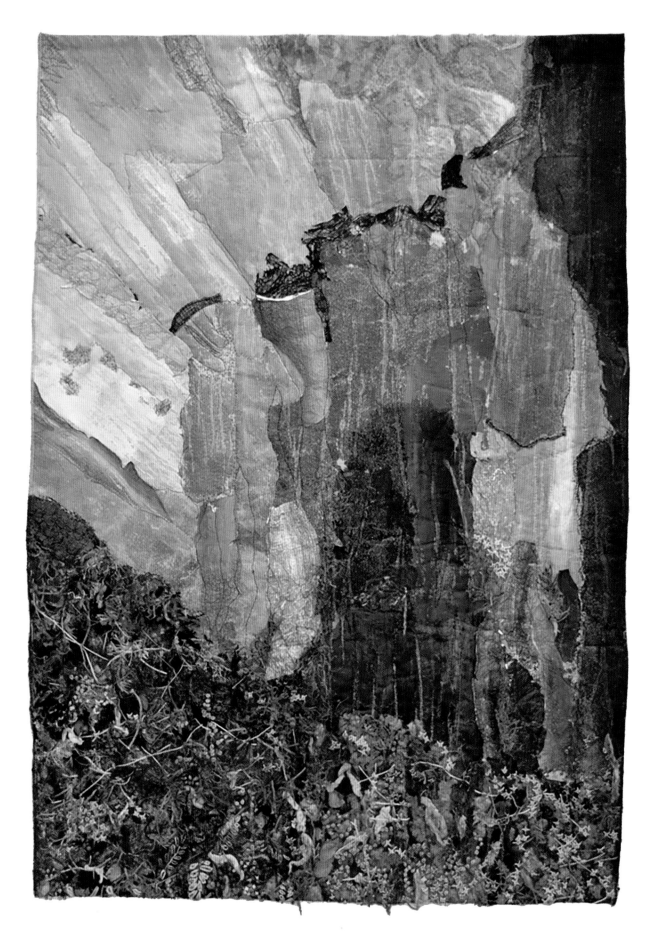

Erosion
33 × 24 inches, 2018

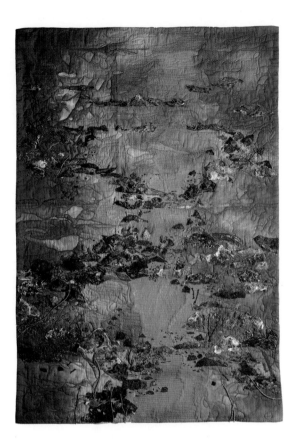

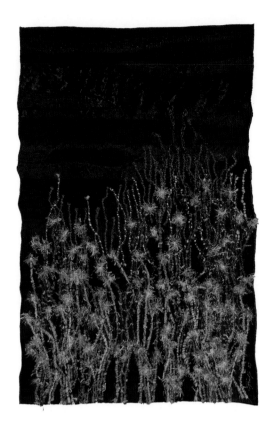

Above left:
Abandoned Mines and the Aftermath
47 × 32 inches. 2018

Above right:
Lamellibracchia
35 × 23 inches. 2007

What's ahead?

In 2017, I was struck with cancer and rheumatoid arthritis. Due to the medicine I have to take, I am not strong enough to work long hours. In order to create artwork within a reasonable period of time, I upcycle my old quilts. I cut them apart, dissect them, remove excess things from the surface—maybe for further use somewhere—and then I reconstruct them into three-dimensional objects: tree trunks, tubes, spirals, or whatever the quilt tells me to do. I thoroughly enjoy it. It keeps my brain busy. It's like playing. For example, an earlier work was transformed into *U-Tubes*.

Just now I am concerned about the catastrophes that harass our world. There are two kinds of them: COVID-19 forced people to go into a lockdown, which led to isolation and loneliness. This was the main topic of my last quilt, *annus horribilis 2020*. I came across the Belgian painter and graphic designer Félicien Joseph Victor Rops, who illustrated the miserable lives of prostitutes at that time. I was fascinated by his art and felt that the themes would also relate to epidemic diseases. The crosses show the growing number of dying people.

The other topic that I am concerned about is environmental pollution. Politicians still neglect dealing with this issue, so I have started to protest against it with my art. And I hope that people will see that they cannot leave finding solutions to these problems to the next generation. *Erosion* is the next piece in this ongoing series.

Light the World

Light is our primary tool for perceiving and understanding the world around us. Without light there is no vision. Light allows us to appreciate the world through shape and form and evokes emotions.

Gabriele DiTota
Florida, USA
In the darkness
46 × 36 inches.
2020

Marian Zielinski
Georgia, USA
What Light from Yonder Window Breaks?
46.5 × 41 inches. 2020

Mary-Ellen Latino
California, USA
Global Guardian Angel
37 × 36.5 inches. 2020

Chiaki Dosho
Kanagawa-ken, Japan
The Glistening Light
40 × 44 inches, 2020

Lena Meszaros
Essonne, France
We are all Lights
46 × 36 inches, 2020

Maya Chaimovich
Israel
A Tiny Moment of Happiness
36 × 36 inches, 2020

Index